Metal Artist's
WORKBENCH

Demystifying the Jeweler's Saw

Thomas Mann

**NORTH
LIGHT
BOOKS**

Cincinnati, Ohio
www.createmixedmedia.com

15 14 13 12 11 5 4 3 2 1

 www.fwmedia.com

Distributed in Canada by Fraser Direct
100 Armstrong Avenue
Georgetown, ON, Canada L7G 5S4
Tel: (905) 877-4411

Distributed in the U.K. and Europe by F&W Media International
Brunel House, Newton Abbot, Devon, TQ12 4PU, England
Tel: (+44) 1626 323200, Fax: (+44) 1626 323319
E-mail: enquiries@fwmedia.com

Distributed in Australia by Capricorn Link
P.O. Box 704, S. Windsor, NSW 2756 Australia
Tel: (02) 4577-3555

SRN: Y3382
ISBN: 978-1-4403-1146-8

EDITOR	Tonia Davenport
DESIGNER	Ronson Slagle
PRODUCTION COORDINATOR	Greg Nock
STYLIST	Jan Nickum
PHOTOGRAPHERS	Richard Deliantoni, Christine Polomsky

DEDICATION

IF YOU ARE A MAKER, if you know what it means to create something new from basic materials, or if you simply want to know, then this book is dedicated to you. I hope the guidance offered here opens the doors of making for you in the same powerful way they were opened for me.

ACKNOWLEDGMENTS

YOU KNOW, of course, that a book of this type is never the sole work of the author. For that matter nothing I make, of any sort, is accomplished solely due to my own efforts. The now clichéd adage that "it takes a village" is completely applicable in this situation as well, except that I would call it overlapping karas'es, or is that karai? And the list of those who contributed in one way or another to the incredible process necessary to produce this work is long.

I am fortunate to have the support of a devoted and talented Thomas Mann Design staff. But without the creative imagination supplied by Angele Seiley, my graphic design goddess and studioFLUX co-inventor, this book would not be. Angele was instrumental in the development of the Learn to Saw™ workshop, workbook and DVD that led directly to the offer to produce this book for North Light Books from their editor and talent scout, Tonia Davenport. Tonia has been a joy to work with on this project, and kudos must also go to the talented and creative team at North Light. They were a pleasure work with during the shoot, and the final result is astonishing.

Copious research was done on the history of the jeweler's saw, and I received valuable direction and suggestions from friends and metalsmithing colleagues Tim McCreight and Charles Lewton-Brain. John Frei, of Otto Frei Jewelry Tools, offered important information on the development of jewelry saw blades. I was constantly inspired by the achievements of tool genius Lee Marshall, who made die forming a dream technique and updated the jeweler's saw for the 21st century with his Knew Concepts saw. I must also mention Al Pine, metal arts teacher and tool mavin, who showed me the possibilities of a "full-service" teaching environment. Many thanks goes to my friends and colleagues, Barbara Minor and Chris Hentz for their project suggestions and their enthusiastic support of this effort.

And last but not least, thanks goes to all of the artists who contributed their work for the Metal Artist Bench Pin sidebars in this book. Their work presented here glorifies the capability on the jeweler's saw as an amazing and wonderful tool in a truly brilliant manner.

Contents

studio FLUX

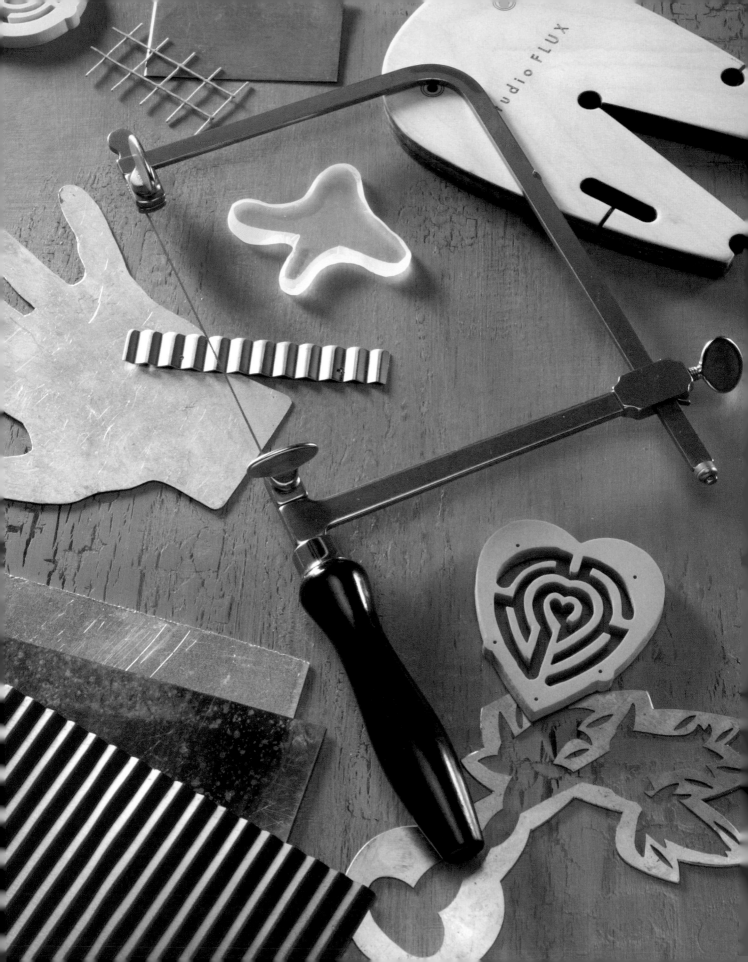

DEMYSTIFYING THE JEWELER'S SAW

In 1963, a student teacher in my high school art classes taught a semester on jewelry making. I learned to saw that semester, but I don't remember how. I don't remember getting any instruction, perhaps just a demonstration. After that we simply had to figure out how to use the saw on our own.

I begged my parents to buy me jewelry-making tools, and they did. Of course, there was a jeweler's saw in that collection of tools. I still have that saw and use it at my workbench today. I believe that this single tool opened up the world of "making" in a huge way. Its ability to extract shapes from a wide variety of materials, combined with the user's understanding of how it does

that and what they have to do to facilitate its abilities, can deliver a truly metaphysical "maker" experience.

Almost everyone is familiar with the most popular cutting tools that will extract shapes from soft or low-density materials—those being the knife and the scissors. But I guarantee that you will be amazed at the capability that the jeweler's saw delivers when it comes to extracting shapes from much harder materials, such as metal, plastics and wood, as well as the more familiar ones like paper, cardboard and fabrics.

The jeweler's saw is simply an amazing tool, one that is essential to the work produced in my studio. Over the course of my career, I have trained some

350 assistants to use this saw effectively. And, because I was paying each and every one of those assistants to learn how to use it, I came up with what has proven to be a fast and effective instructional system. I know this is beginning to sound like a pitch for the Veg-O-Matic, but I am so enraptured with this tool and its capabilities that I am just naturally compelled to share it with you and the world!

I hope the system I've developed to train my studio assistants helps you learn to use this tool effectively and to enjoy it as much as I do. When I'm in the "sawing zone," there is NOTHING else—there is just the flow*. Perhaps you'll find that zone for yourself with this fabulous tool.

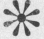 **flow**

In his seminal work, *Flow: The Psychology of Optimal Experience*, Mihaly Csíkszentmihályi outlines his theory that people are most happy when they are in a state of flow—a state of concentration or complete absorption with the activity and situation at hand. The idea of flow is identical to the feeling of being "in the zone" or "in the groove." The flow state is an optimal state of intrinsic motivation, where the person is fully immersed in what he or she is doing. This is a feeling everyone has at times, characterized by a feeling of great freedom, enjoyment, fulfillment and skill—and during which temporal concerns (time, food, ego or self, etc.) are typically ignored.

To achieve a flow state, a balance must be struck between the challenge of the task and the skill of the performer. If the task is too easy or too difficult, flow cannot occur.

The flow state also implies a kind of focused attention, and indeed, it has been noted that mindfulness meditation, yoga and martial arts seem to improve a person's capacity for flow. Among other benefits, all of these activities train and improve attention. In short, *flow* could be described as a state where attention, motivation and the situation meet, resulting in a kind of productive harmony or feedback.

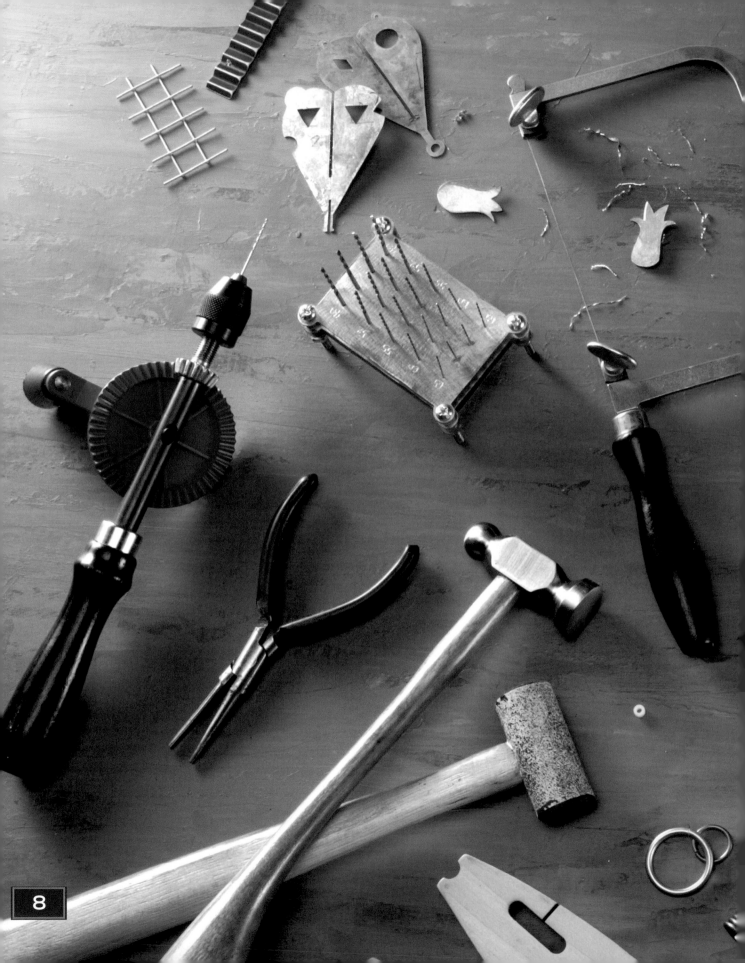

PART ONE: The Saw

This first section of this book is all about how things work and, most importantly how you must work to make those things work. "Those things" are just an extension of the *mind-body-hand-tool connection*. It's this critical connection that we must make with our tools in order for them to perform to their optimum capability for us. It's like realizing the potential of a child and then providing the opportunities for the child to reach that potential. In this case, it's seeing or knowing the potential of the tool and training the *mind* and the *body* to optimize that capability.

I have seen accomplished, professional colleagues use tools in less-than-effective ways but still achieve reasonable results. This is known as "adapting to inefficiency." For instance, I had a guy take a class with me one time who held the jeweler's saw upside down and sawed really well that way! When I asked how he had arrived at using the tool that way, he said, "I just thought that was the way it was meant to be used." His adaptation was so keen, I was loathe to correct him. It occurred to me then that the reason he made that judgment was that when you buy a jeweler's saw frame and blades, it doesn't come with instructions!

What follows here is my attempt to correct that situation by delivering an experience-based dissection of the tools and techniques necessary for GOOD SAWIN' and DRILLIN'.

At the end of this first part of the book, you'll find several exercises designed to build your skill and confidence. If you practice these exercises to the point of proficiency, the rest of the projects in the book will prove to be less of a challenge for you. So . . . GO practice!

Setting up the Workbench

Here I want to introduce you to all of the necessary tools you'll want to consider rounding up when you are setting up your own workbench.

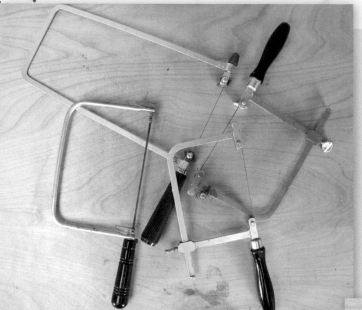

Pictured here is a family of fret saws. Three of them are jeweler's saws. Can you pick out the coping saw? You'll want to have at least one jeweler's saw on your bench. I recommend it be one with a 4" (10cm) depth, but you can buy these saws in a variety of depths from 3" to 14" (8cm to 36cm). The deeper ones are used for piercing shapes out from larger sheets of material.

You'll definitely need a bench pin to go with the jeweler's saw. The traditional bench pin attaches a metal bracket to the face of your bench, in which you insert a blank shaped maple pin that you must cut a V slot into. Many of the artists' bench pins pictured throughout the second part of this book are a version of this traditional solution to supporting and extending the sawing environment off the edge of the bench so there is clearance for your hand beneath it. I don't like this solution much because it also delivers a stepped level difference between the surface of the bench and the pin. That transition puts your material at an angle, and that is NOT good sawin'. My solution is a flat surface pin extending out from the surface of the bench with saw insertion cutouts for full-support sawing of small parts. (The finger hook pictured is simply a fun way to hang stuff and pull yourself up to the bench!)

Basic tools for the workbench: hammers (rivet, planishing, chasing and a variety of forming types); pliers (needle-nose, half-round/flat, round/flat, flat-nose, parallel jaws and a full flush cutter); bench block (polished hardened steel); drill block (plywood); files (variety ranging from needle files to large flat). My favorite files are a 4" (10cm) no. 2 crosscut barrette file and a 10" (25cm) half-round bastard. Miscellaneous: scriber, miniature screwdriver, technical pencil, miniature nut driver, 080 tap, center punch, Tom's Chuck Driver and a tube-cutting jig.

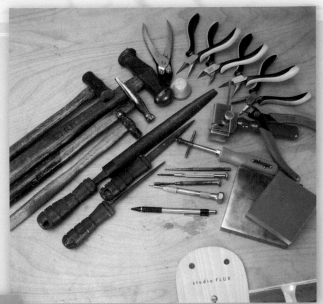

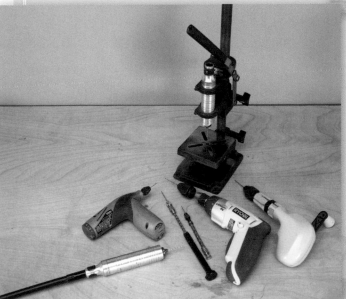

Making holes in materials is an essential metal-smithing technique. You'll need at least a traditional hand drill or pump drill with Jacobs chucks. The best choice is a flexible shaft machine (only the handpiece portion is pictured).

It's important to know the gauge of the material you're working with. The traditional tool used for this purpose is a B&S (Brown & Sharp) wire and sheet gauge for nonferrous metals. These tools are available in disc (shown) and rectangular formats and measure gauges from 0 to 36, with decimal equivalents on the opposite side.

Saw Basics

What Is Sawing?

The noun "saw" and the verb "to saw, sawing or sawed" describe only a general idea of what a saw is or what it does, but say nothing about what is actually taking place where the "rubber meets the road," or, in this case, where the saw blade meets the material. So here is a little more information about one of the most ubiquitous tools on the planet.

A saw is a tool with teeth. It is necessarily made of a substance that is stronger and more resilient than the materials it is designed to cut. It subdivides a material (wood, plastic, metal, cardboard, you name it) by removing a thin section from the body of the material, thus separating the two parts. The negative space left in this process is known as the "kerf." How the teeth of the saw accomplish their mission is different depending on the design of the tool relative to the material it is intended to cut.

In every instance, a saw accomplishes its task by either shredding, chiseling or scraping a path thru the material you wish to separate. This is a critical factor in your understanding of how to operate the tool to accomplish its task, because a *saw* of any type is only an extension of the *mind-body-hand-tool connection*. This understanding is very important in operating a handsaw effectively but is enormously more important when operating a power saw safely.

I've discovered that when the assistants in my own studio and long-time professional metalsmiths and students in the many workshops I've taught are instructed in all aspects of a saw's function, their sawing skills improve dramatically and swiftly.

What Is a Jeweler's Saw?

We refer to this unique variation on the design of the coping saw, which is in the family of the fret saw, which evolved from the bow saw, as a jeweler's saw simply because its use is predominately associated with metalsmiths who make jewelry. What makes it unique is the blade. The jeweler's saw blades are very thin—seemingly fragile things—compared to the blade of a coping saw. However, they have a strength and a resilience that, when understood and used appropriately, can produce phenomenal results. The jeweler's saw's unique capability is that when operated effectively, it can cut very tight curves and corners through a wide variety of materials ranging from paper to plastics to metals. Additionally, I have found application for it in situations completely outside of its designed use.

For instance, I keep a saw frame and blades in the toolbox on my boat and have used it to cut through bolts, cable and wiring in places where no other tool could perform the task as well. I used it to saw out switch plates at home when they didn't fit the size of the switch I had just installed and saved myself the cost of a trip to the hardware store. In short, it's a truly amazing and versatile tool.

The Jeweler's Saw Frame

The saw frame is the gateway to the sawing experience with the saw blade being the gate. I describe the tools of sawing in this way, because for me, sawing can be a very meditative practice. When all of the conditions for accurate and efficient sawing are met, the gate will open, and the possibility of a time-shifting reality presents itself. I know I am leaning heavily toward the philosophical here, but trust me—when you're "sawin' where y'at," the "flow state" presents itself

and the sawing is the only thing that's happenin'.

Reinforcing the philosophical angle here is the condition that the saw frame has a unique historical development and timelessness about it. Even though the jeweler's saw frames you can purchase today look and feel new, they retain many historical design features. The frame's design is essentially unchanged since it showed up on the metalsmith's bench in the early to mid-1800s. What has changed is the increasing sophistication of the saw blades used in it.

Saw Frame Styles & Depths

Saw frames are available in a variety of design styles, saw blade holding scenarios and depths (or throats). But any frame's primary purpose is the support and tension it delivers to the saw blade. The depth of a frame is chosen based on the type and/or size of the material being sawn. A shallow depth frame (3"–4" [8cm–10cm]) would be used to saw wire, ring bands, etcetera, and is most often found on the goldsmith's bench. Deeper frames, up to 18" (46cm) or more, could be used to saw interior, pierced shapes in larger materials ranging 10" x 10" (25cm x 25cm) or larger or simply to saw into a larger sheet of material from the edge. On average, a frame depth of 4"–6" (10cm–15cm) is the most functional size to have available to you on your bench.

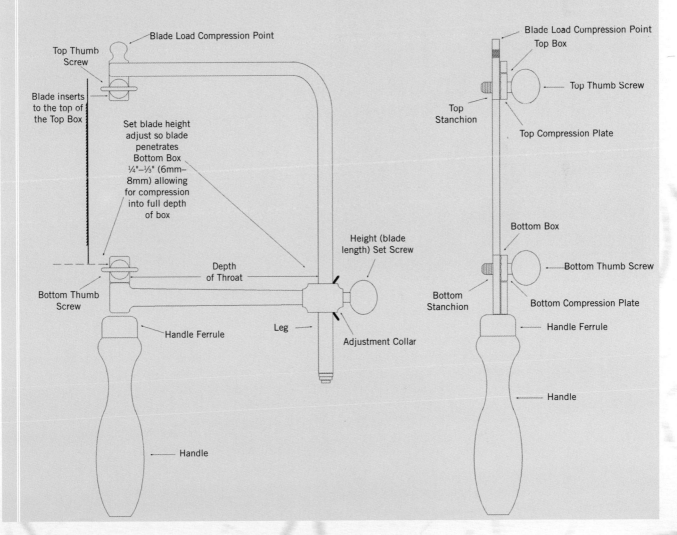

Installing a Saw Blade in a Frame

Most saw frames allow you to adjust the height opening (throat), ostensibly, to accommodate blades of varying length. The fact is that almost all jeweler's saw blades these days are 6" (15cm) in length, worldwide. So once you set the frame for the appropriate distance, it's unlikely you'll have to change it. The one instance when you might make an adjustment to the height of that opening is when that last blade you have breaks and all you've got on hand is a container of broken blades, and there is still a lot of sawing to do. A highly recommended practice, by the way, is to save those broken bits for just such an event. I keep a little magnet handy to pick them up from the bench and the floor, and a jar to scrape them into.

Keep in mind that the most important factor when inserting a blade in the frame is that of proper tension. It is one of the most important factors in efficient sawing. To achieve this, pay attention to the following steps and refer to the diagram on page 13.

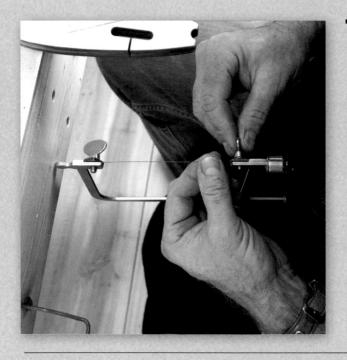

1 Adjust the height of the frame's opening to the size of the saw blades you wish to use. Adjust the height of the opening using the Height Set Screw at the heel of the frame so the blade when inserted extends from the top of the Top Box to ¼ of the way into the Bottom Box. This proper set of the frame opening, relative to the saw blade length, allows the frame to be compressed and the opposite end of the blade to be inserted into the Bottom Box that, when tightened with the Bottom Thumb Screw, sets the "spring" of the frame that appropriately tensions the blade.

Position the frame between you* and a hard surface, like the edge of a table or your workbench, with the Blade Load Compression Point against the hard surface and the blunt end of the handle nestled in the most comfortable part of your anatomy. This is one of the most intimate involvements you might ever experience with a personal tool. As such, it's one that only you* can figure out which anatomical location is best for you.

"You" in this case means a part of your body where you can comfortably handle the pressure you must apply to the frame to compress it approximately ¼" to ½" (6mm to 13mm) in order to descend the blade into the Bottom Box and then tighten the Bottom Thumb Screw to secure it in position.

Personally, I use the base of the sternum bone just above my solar plexus. It will encourage you as well to stay in shape and do those sit-ups and crunches! But some folks use their shoulder or hip. I prefer to do all of this sitting down. You know, efficiency of motion and workspace ergonomics—but that's a whole 'nother book, ya'll!

Alternatively, you could, though it is NOT recommended, use the Height Set Screw to tension the blade. I find this more difficult and less effective than the method described above, so I'm not gonna tell ya' how to do it.

SAW BLADES: A HOT COMMODITY

The option of adjusting the height of the saw is critically important to metalsmiths in the third world where saw blades are a precious and expensive commodity. If you travel to any of these places in the world, take packs of blades along to give away or trade with metalsmith comrades.

2 Pull a blade out of the pack of blades (see the Sawing Troubleshooting section on page 25 for a tip on this) and hold it up to the light to determine the direction of the teeth. They should be pointing DOWN. Then reposition the blade in alignment with the opening in the saw frame so the back (smooth side of the blade) is pointing to the back of the saw frame with the teeth on the front side pointing up and toward you.

With the frame now nestled between you and the bench face, loosen the Thumb Screws at the top and bottom of the frame and insert the blade between the frame Stanchions and the compression pads, making sure the top of the blade is inserted at the very top of the Top Box; then tighten the Top Thumb Screw to snug. (Snug is midway between loose and really tight. Turn too hard and you might strip the threads!)

Now apply pressure to the frame with whichever body part you've decided works best for you, until the bottom end of the blade descends 1/2 to 3/4 of the way into the Bottom Box and tighten the Bottom Thumb Screw to snug.

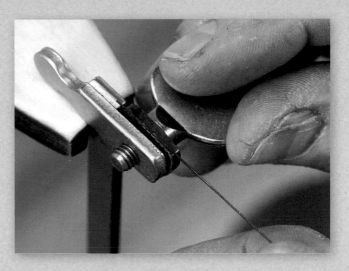

Test the tension by tweaking the blade the way you would a guitar string. It should "ping," indicating proper tension. When you hear that "ping," you're ready to saw. If you don't, try again to tension the frame and retighten the Bottom Thumb Screw.

Saw Blade Anatomy

Understanding how a saw accomplishes its mission is essential to operating the saw correctly and efficiently. In this section we'll scrutinize the structure of *coping* saw blades and *jeweler's* saw blades to discover how they do what they do.

The earliest fret saw blades were crude affairs with a very low TPI (teeth per inch), which made sawing through thin materials a challenging effort. As manufacturing technology advanced, the industry was able to make blades with higher TPI, which made more refined sawing techniques possible. You'll see from the Saw Blade Sizes chart that there is a distinct break point in this TPI count. It occurs between a 0 blade and a 2/0. As the TPI manufacturing capability increased, they needed a new designa-

tion for the sizing of these smaller blades. This is where the "aught" system was born. "Aught" is zero or O in Middle English (11–15th centuries), very quaint. So we refer to a 2/0 blade as a 2-"aught" or a 2-"oh."

Saw Blade Sizes

#4	TPI	35.1
#3	TPI	40.0
#2	TPI	45.0
#1	TPI	50.1
#0	TPI	55.9
2/0	TPI	61.0
3/0	TPI	66.0
4/0	TPI	71.1
5/0	TPI	76.2
6/0	TPI	81.3
7/0	TPI	86.4
8/0	TPI	88.9

TPI

Understanding TPI and its relationship to the material you wish to saw is critical to efficient sawing.

The thickness and density of the material to be sawn will dictate the number of teeth per inch (TPI) of the blade that should be employed. For instance, if you want to pierce an intricate curlicue pattern from a sheet of 26g silver, you'll want to use a finer blade with a higher TPI, like a 6/0 or 8/0, as opposed to sawing a basic geometric shape out of 1/8" (3mm) clear acrylic sheet where you'd want a very low TPI, like a #2 to a #4, or a Skip-Tooth Blade. Remember: Ideally, there are always at least two teeth within the thickness of the material being sawn. More on this later.

Coping Saw Blade, Front View

In this illustration we see what a coping saw blade looks like in front vertical view. The structure of any saw blade is designed to accomplish two things. 1. The extraction of material by the tip of each tooth on the blade. 2. The efficient removal of that material from the gullet of each tooth and the channel being created (the kerf). Jeweler's saw blades are no different. They are designed to scrape a sliver of material from the work face and then release that sliver in order to repeat the same task again and again.

To do this, the teeth of a blade have a "set"—a slight tweak of each tooth alternately left and right of center so the extracted material carried in the gullet of each tooth can be spit out and away as the tooth emerges from the bottom of the work face.

The business end of a saw blade is the very tip of each tooth of the blade. When the saw (saw frame + blade) is used properly, the tooth tips of the blade scrape their way through the materials being sawn. If you apply too much pressure forward and downward, the tooth tips will be forced to CHISEL, rather than SCRAPE, their way through the material. That can stress the blade to the breaking point.

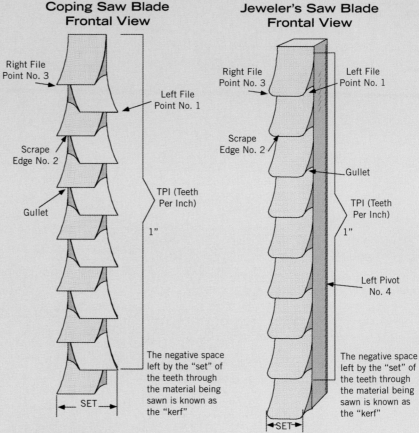

Coping Saw Blade Frontal View

Right File Point No. 3

Left File Point No. 1

Scrape Edge No. 2

Gullet

TPI (Teeth Per Inch)

1"

The negative space left by the "set" of the teeth through the material being sawn is known as the "kerf"

← SET →

Jeweler's Saw Blade Frontal View

Right File Point No. 3

Left File Point No. 1

Scrape Edge No. 2

Gullet

TPI (Teeth Per Inch)

1"

Left Pivot No. 4

The negative space left by the "set" of the teeth through the material being sawn is known as the "kerf"

← SET →

Saw Blade, Side View

Here we'll find one of the most interesting facets of the saw blade's functionality. The "gullet" of the blade actually creates a physical condition in which the "scraping" pulled from the work face of the material is shaped into a spring that will eventually help to propel it outward from the mouth of the gullet as it passes beneath the workpiece and is cleared from the tooth for its next pass. The real challenge for the operator of the saw is in placing their awareness at this infinitesimally minute level of understanding in order to adjust their muscular involvement to achieve the maximum effectiveness of the tool. Heavy stuff, huh?

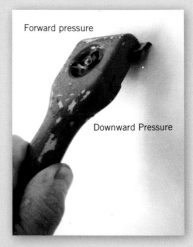

Forward pressure

Downward Pressure

Scraper Tools

The paint scraper and the saw blade are cousins. The saw blade is a scraper, too!

Contemporary Jeweler's Saw Blade (Rounded Edges)

Within the past forty years, the jeweler's saw blade has been transformed once again. The "set" in the blade has been eliminated because it created a wider kerf, which wasted precious material. Where the blades used to have square corners, they are now rounded. The "set" was critical in softer materials, like wood or plastics, for the gullet to clear itself,

but wasn't a factor when sawing harder materials like metal.

The blade's ability to clear itself is now that much more dependent on the gullet of each tooth, and therefore the **feed rate** factor (see page 23), to perform its springing action to spit out the shavings. This means that your sensitivity to the nature of the material, the TPI of the blade, and all other sawing factors has to be insightful.

Jeweler's Saw Blade Side View

View of the blade from the side

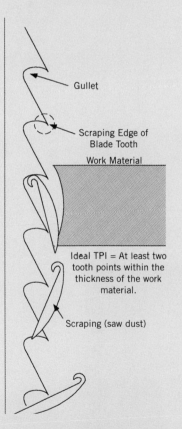

Gullet

Scraping Edge of Blade Tooth

Work Material

Ideal TPI = At least two tooth points within the thickness of the work material.

Scraping (saw dust)

Jeweler's Saw Blade Down View

Looking down the blade from the top teeth pointing downward

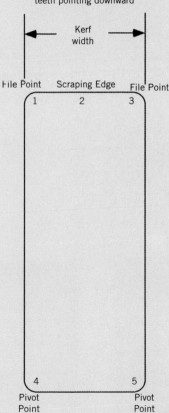

Kerf width

File Point Scraping Edge File Point

1 2 3

4 5

Pivot Point Pivot Point

Blade Down View

The jeweler's saw blade is, actually, two tools in one. It's a saw and a file! The rounded points of the teeth on either side of the blade are extremely useful files. They can be used to file an edge to remove the marks they made as the scraper (tooth point) cuts its way through the material. More important, they are critical to successfully turning the blade as you navigate your way around sharp corners. When we instruct sawing with our apprentices in my studio we use a technique I've developed, called SawFile. That is, sawing and filing at the same time. This means when you're in the groove, your sawing is so accurate that, when completed, the only reason to file the edges on your workpiece is to remove the saw marks. If you are filing after you've sawn a piece out to "edge correct," meaning you have to file the piece afterward to get it to conform to the pattern you were trying to follow, well then, that's NOT GOOD SAWIN' and you are *not* SawFiling.

There are five critical parts to the jeweler's saw blade. Observe the Jeweler's Saw Blade Down View illustration. You'll notice that No. 1 and 3 are files as described above. No. 2 is a *scraper* that should never become a *chisel*. No. 4 and 5 are pivot points that are critical to making successful turns.

The Bench Pin

One of the four components of a wonderful sawing experience—besides YOU, the SAW and the MATERIAL to be sawn—is the BENCH PIN. Just as the saw frame and blade are an extension of your mind and body, so too is the bench pin an extension of the workbench.

They come in all shapes, sizes and functions. They are made from a wide variety of materials. Maple and oak traditionally have been preferred, but I have been making mine out of plywood. I have some commercial pins that are used only for splitting ring bands or jump ring coils. There are traditional forms and modern ones. I have designed my own specifically for the way we work in my studio relative to the kind of jewelry we make. No matter the form, they are all essential to the sawing experience because they serve several important functions. 1. They are a safety device. Used properly, they will protect you from inadvertently sawing into your fingers.

2. They extend the work surface off of the bench to allow clearance for the necessary movements of your hand and the saw frame in the sawing process. And 3. They support the work and provide a stable platform, eliminating vibration and wobble, an essential condition to GOOD sawin' operations.

A bench pin should provide a stable platform for the sawing operation. Most bench pins come as blanks, ostensibly so you can cut them to your personal specs. If you don't have a band saw handy in your shop, you'll have to use handsaws or maybe even your jeweler's saw frame with a #3 or #4 blade, to saw out a wedge, giving you the traditional form of the bench pin. You could also use a coping saw for this. The bench pin should be solidly mounted in its holder—usually cast iron or steel. I have found that in most cases the shank, or stem of these pins, must be trimmed and shimmed into the holder to get it snug enough to provide that stable support.

I cut my pins to accommodate the peculiar way I make jewelry. I am often sawing small parts, so I need support for those small pieces. I cut a lozenge-shaped slot in the left point of the pin and drill a $\frac{1}{4}$" (6mm) hole in the right point. Each has a cut from the outside of the pin through which I can slip a blade in sideways and saw little bits that are then completely supported. The front of the pin has indentations cut in as well—one half round, the other V-shaped—for positioning objects for filing and shaping operations. I insert a miniature fillister head screw in a no. 55 drill hole or a 16g ball-headed rivet in the flat upside tip as well, as a stop on the flat surface for objects I am shaping.

The Sweet Spot: Every bench pin has one. It's where the vibration of the sawing operation is optimally minimized. Usually this is at the very depth of the big V cut. You'll want to know where the sweet spot in your pin is as that's where you'll want to be for the best sawing results.

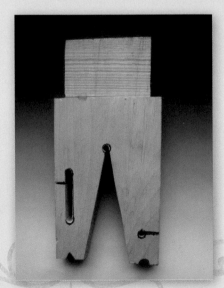

Ergonomics: The Whole-Body Experience

Sawing efficiently is a whole-body experience. It's not just the hand that does the work. The hand is at the end of an arm attached to a shoulder, which is part of a torso, that's sitting on a chair, etc. The proper ergonomics of the body in relationship to your bench and tools will factor tremendously into your physical comfort level and, as a result, your work stamina.

Adapting to Inefficiency

You got this great new tool that performs this really cool function, and you just know it will add a certain pizzazz to your work. It didn't come with any instructions, so you break it out and just start using it as best you can. You get reasonably good results. You do this now on a regular basis, and you're just groovin' along till one day a colleague of yours spots you using this new favorite tool and points you to the "correct" way to use it. Wow, it works even better and gets the job done even faster. What you've been doing up till this point is what is known as *adapting to inefficiency*.

Addressing the Bench

Whether you're using a workbench or a simple tabletop for your sawing environment, there are some key factors in the body/bench relationship. So here are several things to consider.

Seating-to-Bench Height

Goal: A sawing position that minimizes stress on your back musculature and skeleton. You want your back as straight as possible, no hunching over. Seat height can vary from 15" to 20" (38cm to 51cm). Bench and table heights range from 26" to 40" (66cm to 203cm). (See Resources on page 140 for our EasyBild Bench Buliding Plan.)

Remember, the goal here is to lower the impact on your body, so play with varying seat-to-bench-height ratios to find the one that's right for you.

Body-to-Bench Orientation

To saw efficiently, you must position your body in relationship to the bench and bench pin in such a way that your arm has clearance to move freely. If you're right-handed, you want to position your chair to the left of the pin and angled slightly toward it. Make sure your elbow passes freely past your right side. If you're a lefty, like me, just reverse this position.

Mother's Warning!

Sit up straight! Shoulders back! Grab that saw frame. You're ready to saw.

19

The Thomas Mann studioFLUX
Sawing Technique

Remember, the real sawing skill you want to develop is a combination of your knowledge of how the blade and frame operate filtered through the intuitional feedback loop you are building with the tool.

Goal: To SawFile—saw and file at the *same* time.

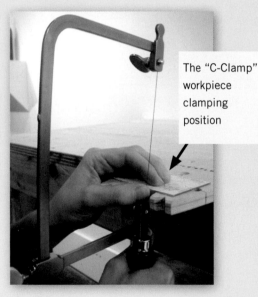

The "C-Clamp" workpiece clamping position

The C-Clamp

When setting up a sawing operation, the natural inclination is to clamp the workpiece to the bench pin with a pinching action with the thumb underneath the pin and the remaining four fingers on top. If your grip is strong enough, this will work just fine, but in the long term it will stress the joints and ligaments at the base of your hand. The mo' betta' technique is to curl the four fingers on top in the shape of a C-clamp, and using the weight of your shoulder and torso, compress the workpiece against the bench pin surface.

The Proper Grip

The real trick to all of this sawing business is in the grip. If you consider that the tool (the saw frame) is an extension of the mind-body-arm-hand system (and what a wonderfully complex and elegant system it is), then the manner in which the saw frame is held must be an equally elegant act.

Most saw frame handles have a beautifully intuitive shape to them (see page 13) that is not without purpose. The first concave inward curve of the handle is designed to fit the crotch of the hand between the forefinger and the thumb so sweetly that you can literally saw without grasping the handle with any other fingers simply by flexing these two fingers together at their bases. This compression is enough to be able to move the saw delicately in the up/down motion necessary to begin the sawing action. Try it. One of the amazing things you'll discover is that the blade possesses a natural intention: it just wants to cut. It's akin to the samurai blade that has only one purpose: to cut. With very little pressure applied in this experiment, you'll find that the blade just starts cutting its way into the material of its own volition.

Now gently wrap the remaining three fingers of your hand around the "pistol" of the handle, starting with the little finger. Grasp gently and firmly but not tensely. In the end you'll be sawing without ever curling the forefinger and thumb into the grip. This is the VELVET GRIP—the one that gives you the most control, the most comfort and the most delicious sawing experience.

The Velvet Grip

This grip delivers the best ergonomic-to-strength strategy for operating the jeweler's saw frame. Resting the "leg" of the saw frame against the side of your wrist helps align the saw frame with your arm for optimal MIND-BODY-HAND-TOOL CONNECTION.

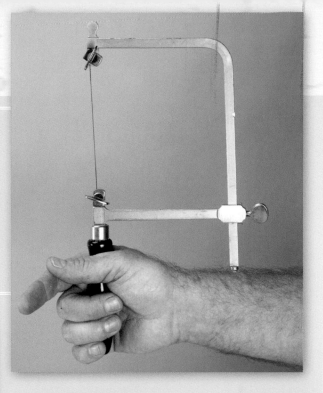

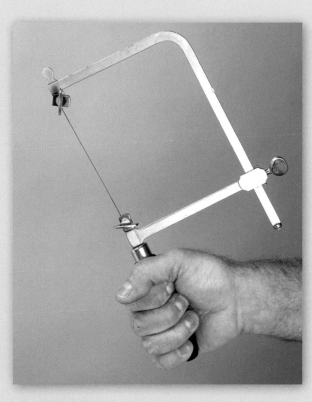

The Death Grip

This grip should be avoided at all costs. You lose a lot of directional control with this grip because a hard grip "muscles" the tool and clouds finesse.

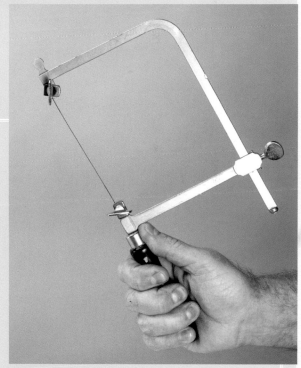

The Thumb Block

This grip is bad because it forces the frame into a forward angle. The blade will now saw through a thicker band of material and turning becomes dangerous to blade survivability.

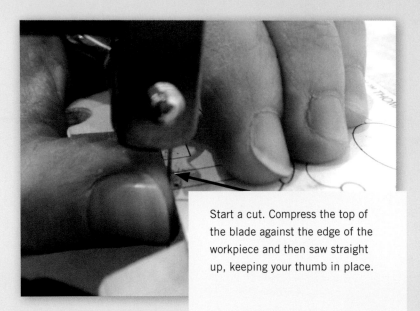

Start a cut. Compress the top of the blade against the edge of the workpiece and then saw straight up, keeping your thumb in place.

Vertical Sawing

You want to try to operate the saw in a straight up and down motion in two axes, X and Y, but the fact is, because the tool is held at the end of what is a lever (your arm), with a semi-stationary pivot point (your elbow), it actually moves in a shallow arc. That's why the slivers that are scraped from the work face of the material will have a crescent to curlicue shape. If you were able to really saw straight up and down, the slivers would be thin, rectangular and only slightly curved. (See the Maze Pendant on page 90 for the Tomboy Saw Frame Leveling Tool!)

How to Start a Cut

If you're sawing into the material from the edge, I've found a little trick that works very effectively.

Place the blade against the workpiece at the very top of the blade but not snug up against the Top Box. Place the thumb of your opposite hand behind the blade and against the edge of the workpiece. (Note: you'll be doing this at the same time you're holding the workpiece firmly down against the bench pin.)

OK, now in a steady motion push the saw frame upward in one stroke. The teeth of the blade, even in reverse, will carve a shallow notch in the workpiece, giving you a wonderful little slot that will contain the blade as you begin the first downward pull of the frame and blade. Begin that first pull with very light forward pressure on the frame.

As the blade moves, you gradually increase that pressure into a normal sawing stroke.

Warning! Cold starts at full pressure break blades. The blade must be in motion before you apply full pressure, and "full pressure" is relative to the type of material, its thickness and the TPI of the blade you're using.

What this sequence indicates is that most of the cutting action takes place in the center 1"–1½" (3cm–4cm) of the blade. When your wear a blade out because you've SawFiled so effectively, this is where the blade snaps. The completion of a saw stroke uses lighter pressure. So, light pressure as the saw is put in motion, full pressure in the middle of the stroke and tapering off to light pressure as you end the stroke.

Sawin' Where Y'at—The Big Trick

You only have to control the direction of the blade as far as it will travel through the material in a single stroke. This is what we call Sawin' Where Y'at. It's a kinda Zen thang! If you place all of your attention at the point where the blade meets the material (work face) and are mindful of the blade's progress along your design's outline path, you will be SawFile'n. How? Because, you KNOW how far the blade can travel through the material in one stroke, and you KNOW that you only have to control its direction for that very short distance. Do that repetitively, intuitively and you'll be in the SawFile'n Zone.

Feed Rate & The SawFile Formulae

This tongue-in-cheek formulae states what's already been said. But we should talk about what is known as *feed rate* because every cutting tool and every saw has one. Feed rate is the optimum speed at which a material can be fed into a saw blade and still be sawing at maximum efficiency. This is also true of a blade that is being moved into the material by pressure from the operator, which is you. Your job is to determine what that feed rate is and then deliver to the tool—through the mechanism of your arm and hand—the correct forward and downward pressure to achieve optimum cutting capability of the blade to excavate a path through the material.

SawFile Formulae

$$(Fp + Dp) \times (MDT - TPI) = Fr$$

(forward pressure + downward pressure) x (material density/thickness – teeth per inch)
= feed rate

$$Fr \div Oc = BTDperS$$

feed rate ÷ operator capability = **blade travel distance per stroke**

Piercing

No, we're not talkin' about body piercin' here, just workpiece piercing. This term refers to the process of sawing out a shape from the interior of a sheet of material. It always involves inserting the bottom end of the blade, while the top end is still snugly captured in the Top Box of the saw frame, through a hole you've drilled in the workpiece, reinserting it in the Bottom Box and respringing the frame, just as you would if you were inserting a new blade. Then you can saw out that interior shape. The term has come to be applied to the sawing operations in general, but originally it referred only to the action just described.

THE MYTH OF LUBRICATION

Nearly since the dawn of the Machine Age, whenever someone would purchase a jeweler's saw frame and blades, they'd also be encouraged to buy a stick of beeswax. This less-than-subtle encouragement implied that the blades required lubrication to work efficiently. This is NOT the case. In fact, jeweler's saw blades were never designed to need lubrication. "Lubing" your blades actually inhibits the acquisition of advanced sawing skill by psychologically handicapping you into believing that waxing makes you a better sawer. It only gives the illusion of more efficient sawing, and it's a temporary state.

Wax as a lubricant only works when the temperature generated by the cutting action is hot enough to liquefy the wax. And that never occurs with jeweler's saw blades (but does with drills). If your sawing action is getting hot enough to melt wax, there's definitely something running amuck!

There are only a few instances when waxing your blades with beeswax or any of the contemporary wax lubricant products can make a difference. Sawing actions in gummy metals such as heavy gauge copper, aluminum, or harder ones like steel, can benefit from waxing.

The BEST lubricant is the ATTENTIVE mind that operates the body, that MOVES the saw, that CUTS the material.

Turning a Corner

Turning a corner of any degree is probably the most challenging action in the sawing pantheon. But here's a new perspective and technique I've developed that has proved to be a very successful one. Remember the Blade Down View (page 17) and the five function points described there? You'll recall that points 1 and 3 are file points, and points 4 and 5 are pivot points. To turn a sharp corner involves the use of the smooth corners of the back side of the blade. Whoever knew they had a function?

As you saw into the material (this is particularly evident when the material is metal), the file points at the tips of the scraper leave little ridges in their wake. These ridges can now be employed as traps for the rear corners of the blade. When you want to turn to the right say, the action is as follows. (Note: Steps 1 and 2 happen with the blade moving up and down and IN place. No movement forward is appropriate.)

Once this technique has become automatic your intuition will direct your sawing and you will never ever look back at those turns!

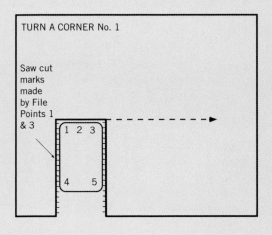

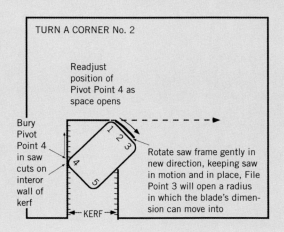

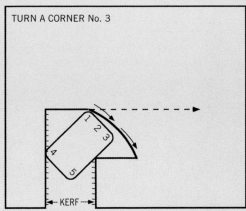

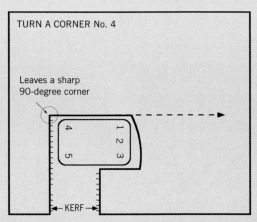

1. Turn the frame ever-so-slightly in the direction you wish to go and gently pull backward on the frame, moving the frame slowly up and down but in place.

2. Slowly rotate the blade toward the new direction, still maintaining the slow up-and-down action and the slight pressure backward. In this case, file point No. 3 will slowly nip a radius out of the material and effectively clear a negative space that will allow the blade to turn unobstructed in the new direction.

3. Now saw forward, maintaining the attention that you only have to control the direction of the blade one stroke at a time, and you'll be Sawin' Where Y'at.

Sawing Troubleshooting

Remember: When a saw blade breaks there is only ONE time when it would actually be the blade's fault, and that is when it is "worn out" because the operator of the saw has used it so efficiently and for so long that it actually fails because the teeth are worn down. The now "work hardened" blade snaps because it can't hold the tension from the spring action of the frame.

Every other time the blade breaks, it's gonna be *your* fault! So here's a short list of troubleshooting ideas to help you figure out why the darn blade broke.

Note: Sometimes the blades are simply of poor quality and will drive you crazy. Blades of the proper quality are an important element of efficient sawing.

Mounting the Blade into the Saw Frame:

The opening set for the saw frame was too high, and you had the spring of the frame closed so much that it delivered too much tension to the blade and stressed it beyond its design parameters.

Turning a Corner:

You stressed the blade by forcing it into the turn before you developed "clearance" for it using the Sawin' Where Y'at turning technique.

Check the angle of the blade relative to the workpiece. Are you sawing straight up and down? No? That is likely the cause. A blade can only turn effectively through one axis. If you are sawing at an angle, you'll be asking the blade to make the turn through two axes, and it doesn't like that!

The Blade Got Pinched in the Kerf:

Even support is probably the issue, and/or the elimination of vibration or "flopping" up and down. If the workpiece isn't supported evenly, it can collapse into the negative space of the bench pin, squeeze the kerf and pinch the blade. Stop, look closely, assess the situation, and then gently and cautiously bend the offending pieces back to flat and release the blade from its confinement. Make sure you're holding the workpiece firmly against the bench pin with the C-Clamp Hold (see page 20) to prevent flopping.

You Just Looked at It:

Better check the power of that "look" and look a little closer.

OPENING A PACK OF BLADES

Saw blades usually come in a package of one dozen* and are wrapped with thin brass wire. They terminate at each end of the pack in a "collar" of wire. The shop trick to open them quickly is to hold the pack in one hand and, with the fingernail points of your index finger and thumb on the other hand, grasp and compress the pack just below that collar. Pull sharply in line with the pack and snap that collar off. Peel out an inch or two of the thin wire that is left, rotate the pack to lie across the three big open palm fingers of the opposing hand, thread the wire between two fingers and pull. You'll roll and unravel the pack. I keep the loose blades in a tube of copper with a flattened end through which a hole is drilled and, with a drywall screw, attached to a shelf edge on the back side of my bench.

* A dozen is a familiar unit of quantity equal to twelve. Division into units of twelve rather than ten has the advantage of being evenly divided into halves, thirds or quarters. For this reason, units of twelve have been common since the earliest civilizations of the Middle East. "Dozen" comes from an old French word *dozaine* related to the Latin word *duodecem*, "twelve."

Drill Basics

The Nature of Drills

The term "drill" is both a noun and a verb—just like "saw." In this description a drill is the tool that carries and delivers power to the drill bit.

Drill bits are amazingly similar to saw blades! Really, they are. The only significant difference is the direction in which they scrape their way through the material to be cut or drilled. While a saw blade tooth point works by scraping up and down vertically, the drill bit does the same thing circularly. The trick to successful drilling is to understand how the drill does its work and to understand the nature of the material you wish to drill. You must match the drill type with the hardness factor of the material, and then add the components of speed and pressure, also known as the FEED RATE. Get all of that right and you'll be drilling like a champ.

Twist Drills

There are many types of drills, for many different applications. For the drilling scenarios described in the projects in this book we will only be talking about twist drills. Twist drills were invented in 1861 by Steven Morse in Massachusetts, and were originally made by cutting two flutes into a rod, and then twisting the rod to create the relief channels we are all familiar with. Now those flutes are cut as the rod is turned into the cutting head of specially designed grinding machines. These flutes are comparable to the gullet and set of the jeweler's saw blade (see page 17). Both are an integral part of the cutting (scraping) action in that they allow for the efficient removal of the scraped-off material, known as swarf, from the work face.

A drill bit has two principal parts: the scraper with its supporting flutes and the shank. The scraper is the equivalent of the saw blade tooth tip.

In metalworking, the most common form of the twist drill used is known as a high-speed twist drill. It is made of a very hard steel alloy. The scraper of any drill is found at the leading edge of each flute and is most commonly ground to a 118° angle, which will work just fine in metal, wood and harder plastics.

If the bit tends to wander or dig into the materials, it may indicate that the cutting angle is not optimum for the material you're drilling into. Unfortunately, the drill bit sizes addressed in this book aren't available in any other angles.

So, for instance, I find that a brand-new drill bit in the no. 80 to no. 48 range (the sizes addressed in this book), or for that matter any fresh bit of any size, that is being used to drill acrylics (plastics) tends to bite into the material too fast, regardless of your careful application of feed rate, because the scraper's edges are too sharp. As a result, they tear into the material with a tendency to bind and fracture the material, rather than scrape it away from the work face. The ideal angle for the twist drill's scraping edge in this case would be 90°, but you're never going to find that in these size ranges.

I save all of my dulled drill bits for use on plastics because I have found that a dull bit works much better than a fresh one for most plastic/acrylic materials. I have even resorted to dulling a fresh bit for use in acrylics and other plastics.

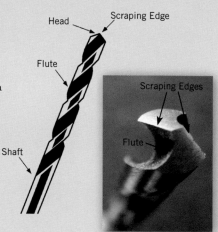

Head — Scraping Edge

Flute

Scraping Edges

Flute

Shaft

Feed Rate (Again)

The same issues of forward and downward pressures that apply to sawing apply to drilling as well. Except that here you will more than likely apply the rotational force to the drill bit with a powered device (i.e., flexible shaft hand piece, battery drill or vertical drill press). The downward force is up to you. The combination of the two, combined with your read* on the hardness of the material to be drilled, becomes the feed rate.

*Ascertaining, then facilitating the optimum capability of the drill bit's cutting potential. Whew . . . it's a big job!

Drill Sizes

Drill bits are available in several sizing systems: fractional, U.S. number and letter, and metric.

The fractional system is based on the English system of measurements, which is based on the length of King Henry I's foot. This wacky system that we still seem to be culturally addicted to (and which caused no end to my adolescent angst, trying to inculcate quarters, eighths, sixteenths and thirty-seconds into my little brain), is in fact less-than-accurate when it comes to machining precise parts. So the inventive Americans came up with number and letter drill systems based on thousandths of an inch. Brilliant! No? . . . No! In fact, the rest of the world—for the most part—uses the metric system of measurement, which is based on units of 10 and is the most precise method of sizing anything. But I have discovered the happy medium in all of this confusion and that is Number Drills. This system sits comfortably between the fractional and metric systems and makes me happy. So all drill sizes in this book will be Number Drill sizes.

Drill Bit Sharpening?

Yes, it is possible to sharpen your drill bits, but . . . it's tough to do on any bit smaller than ⅛" (3mm), so you're pretty much outta luck with the bit sizes we're dealing with in this book. The critical factor in sharpening a bit is the angle. It's almost impossible to do it accurately by hand, even with bits large enough to actually SEE the cutting edges. There are drill bit sharpening machines you can purchase that will do this pretty well, but none of them can do it on a bit smaller than ⅛" (3mm). So it is likely that when you wear out a bit smaller than this, you're gonna chuck it and reach for a new one from your Drill Bit Index (page 42). I keep all dulled bits for use on acrylics; you might too.

Lubrication

Unlike saw blades, drill bits love lubrication. If you're using a wax as your lubricant (beeswax, Burr Life or other similar wax products), the frictional heat produced by the drill bit in contact with metals will melt the wax, which then flows into the shaft and lubricates the cutting head of the bit. (Note: lubrication isn't necessary for softer materials such as wood or plastics.) In drilling operations using a larger bit size (i.e. larger than ⅛" [3mm] or no. 33 bit sizes, or for smaller bits in thicker metal materials), a cutting fluid may be advised. Cutting fluids, compounds and oils can be formulated from a wide variety of natural oils and organic compounds but are most commonly a petroleum distillate. They are available from machine tool supply houses, your local hardware store or megamart and come in dispensing cans, like 3-in-1 oil.

Drill Types
Hand Drills & Pump Drills

Got Power? No? Then you should consider having either a hand drill or a pump drill, or both, in your tool inventory. I take a little kit of small portable tools with me on vacations for that spontaneous gotta-make-something moment, and the pump drill is an important component of this kit. The pump drill works (single-handedly) when you push the drill tip into the material being drilled. The compression forces the shaft of the tool to turn the drill bit slowly. It's drilling at its simplest.

The hand drill is a two-handed tool and works parallel to a powered drill. One hand holds the tool in position, and the other turns the handle that drives a gear that turns the chuck and the drill bit.

Note: Both of these drills employ a Jacobs chuck* to hold the bits. DON'T travel with the bit in the chuck. This makes the bit more vulnerable to breakage and, if traveling by air, completely freaks out TSA inspectors!

The Jacobs chuck was invented by A.I. Jacobs after a knuckle-bruising incident with a late Industrial Age drill press. He came up with the idea of a device that would gradually close three or four articulated jaws around the shaft of a drill bit, securing it for the drilling operation. The chuck is tightened either by the use of a special key or by turning the chuck collar against a temporarily stabilized shaft stop.

BREAKING BITS

If you hear your drill bit "creaking" as you pressurize it into the material you are drilling, it's telling you it is about to break and desperately wants to be lubricated. So dip the cutting point of the drill in a block of wax or a cup of oil and proceed.

Cordless Drills

If you don't already have a cordless drill, get one. This is an essential tool for any serious metalsmith. Besides its primary uses—driving tech screws (drywall screws) for building and attaching all kinds of stuff in your studio (download the EasyBild Bench plans from thomasmann. com)—it also has many applications in the metalsmithing realm. Make sure to buy a drill that has a Jacobs chuck that closes down tight on small drill bit sizes. If, when fully closed, there is still a gap in the chuck's jaws, it might not close on the smallest bits. In this case you'll have to insert a Jacobs chuck adapter to hold the smaller drill bit sizes.

Drill Presses

When you hand-hold a cordless drill, rotary tool (such as a Dremel), or flexible shaft handpiece, there is always going to be a less-than-precise alignment issue. As much as

I encourage you, and you strive to perform efficient ergonomic tool use at the bench, there are always going to be variables in the human system that produce inaccurate results. So if it's critical that the hole you're drilling be at a precise angle, you might want to use a drill press. Small bench models in a variety of price and quality ranges are available that will accommodate the smallest of bit sizes. But the one I love allows for the mounting of a flexible shaft hand-piece in it, which then attaches to your flexible shaft machine.

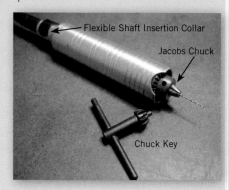

Flexible Shaft Insertion Collar

Jacobs Chuck

Chuck Key

Flexible Shaft Machines

These indispensable jewelry-bench machines were a product of the Industrial Age in England in the mid-1800s. James Hall Nysmth invented the first version of the machine in 1829 when he wanted to reach an area of a machine he was working on that he couldn't reach with a drill press. Once the invention became known outside of the shop in which he worked, it was quickly adapted to other industries—in particular, dentistry. It wasn't long after this that the flexible shaft machine, with the advent of electrical power, evolved into one

of the most useful machines employed by jewelers. The Foredom Co. of Connecticut has been the foremost manufacturer of flexible shaft machines in the United States since 1922.

The essential function of these tools is the transference of the rotary motion of the motor via a flexible metal cable to a handpiece. The handpiece most commonly employs a Jacobs chuck to secure and hold a range of drill bit sizes ranging up to $\frac{1}{4}$" (6mm). But I do NOT recommend ever using a bit size this big for any flex-shaft drilling operation. If you want to drill a hole larger than $\frac{1}{8}$" (3mm), go to the drill press! You can also "chuck up" a wide variety of other shafted burrs, brushes, grinding and finishing tools in the handpiece for a wide variety of jewelry-making applications. The variable speed of a flexible shaft machine is controlled by a variable speed foot pedal. This leaves your hands free to manipulate the handpiece and what you're working on. Look for one that delivers an even, strong torque through all speed ranges.

Torque is critical to cutting actions at slower speeds—the range where drills do their best job.

Rotary Tools

This tool has three significant disadvantages when it comes to drilling operations. One, the motor is in the handpiece, and its weight makes maneuvering and positioning the bit more difficult. Two, the chuck is a collet chuck, which means that all bits have to be structured for the collet size (making them much more expensive), or you have to insert a Jacobs chuck adapter. Three, they have little to no torque. As you pressurize the bit into the material, the motor slows down with the load. So they only really work at high speeds and for a brief period of time. All of this makes for NOT good drilling. (Sorry, Dremel.) On the other hand, the Dremel vibratory Engraver is one of my favorite and most useful tools.

Collets vs. Jacobs Chucks

A collet-driven chuck uses a split cylinder with a slightly bulbous head to cinch a shaft inside its diameter when a compression collar is turned tight on the closing dimensions of the collet. Collets are necessarily limited in the compression they can deliver to a shaft by their dimensional restrictions. This means you can change collet sizes, but each one is limited to a particular shaft size. So any rotary tool expression must be wedded to a shaft dimension that will slip into the collets accommodated by the tool you have available to you.

You can also purchase handpieces for flex-shaft machines that use a collet system. They are often referred to as "quick-change" handpieces. They do what they say they'll do—but they require lots of maintenance to do that. The Jacobs chuck handpiece is, for the money, the best solution to successful flexible shaft drilling.

Multiple Handpieces

My production studio solution to the quick-change collet is to install multiple flex-shaft units at each workbench and also provide multiple handpieces. Instead of re-chucking primary drill bits or burrs in one handpiece on one machine, my assistants and I simply change handpieces with chucked-up primary bits or burrs in each. This takes less time (trust me, we time-studied this!) than the ergonomic manipulations of the chuck key into the handpiece to resize it for the differentiating shaft diameters of drill bits and other burrs.

Drill Methods
Using the Center Punch

Examine closely the tip that is the heart of any drill bit's pointed cutting pinnacle, and you'll soon realize that it will, when compressed against a surface, make a very slight impression in that surface. But put a little rotary motion on it and it's likely gonna wanna dance all over that surface. That pointy end is begging to be contained so it can lead the sharpened flute ends of its sisters to their appointed task of scraping away at the material they have been directed to carve their way into. Enter the center punch's role in this drama.

A center punch is a steel rod approximately 3"–4" (8cm–10cm) long and a ¼" (6mm) or larger in diameter, one end ground to a shallow point, and then heat-treated to retain its hardness. This tool is driven into the target material (a malleable metal surface) with a driving device (i.e., a hammer) to create a shallow depression. This activity is known in metalsmithing terms as "chasing." The divot it creates in the metal surface literally pushes metal out of the way of the pointed end of the tool. Look at it from the horizontal landscape perspective, and it really looks like a volcano pushing up from the surface of a plain. But I digress. . . . When the point of the drill bit is placed into this little period-point divot in the surface of the metal and you step on the flexible shaft machine's foot pedal, *voilá!* The bit won't dance around, but will dig in and do its job!

Using the "HDP" (Hand Drill Press) Technique

I think of this as the "turn your hand into a drill press" technique because you can completely control the range of motion of the flex shaft's handpiece and the drill or burr in its Jacobs chuck. If you're drilling through a sheet of 20g metal, the distance the drill has to move from the starting point to full penetration of the sheet is less than a ¼" (6mm). In order to completely control this range of motion, you must hold the handpiece in what I call a "Vertical Finger Grip with base of the hand" leverage point. The base of the hand is positioned at the edge of your drilling pad or bench pin.

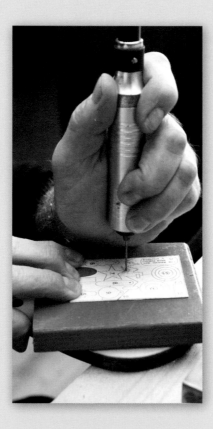

In fact, there are only two grips that are effective in using the handpiece: the HDP and the Forward Fist Grasp, meaning that the handpiece is held as you would the handle of a saucepan. The Downward Fist Grasp is the equivalent of the Death Grip I described in the sawing section of the book (see page 21). The problem presented by Death Grip is stopping the drilling pressure. When you grasp the handpiece in this position, it is similar in effect to what happens when you grasp the saw handle the same way. This grasp transfers control of the small muscles in your hand and arm to the larger muscles, and they do not respond quickly to brain signals telling them to stop. Instead, they have a delayed response to the request and tend to overreact. So if you are pressurizing a drill bit into and through the same metal sheet with this grasp, the drill will penetrate the metal and then just keep going. Your brain tells it to stop but by then it's on its way into the drill pad. When it does react to the signal, it jerks upward and, because it's at the end of your arm, which is level, it's coming up in an arc. This flexes the drill bit in the shaft it's created and can easily break. It's just NOT good drillin'!

Drilling Without Center Punching

Remember that in a production studio you're always looking for shortcuts to effective and efficient production of the target object. So one of the techniques I've developed over the years in teaching my assistants is to "center point in place." It's a tricky little thing.

Here's how it goes: Using the "HDP" technique described above, place the point of the drill bit in the precise spot you wish to drill. Keeping the handpiece absolutely vertical and centered in alignment over the handpiece and chucked drill bit shaft, gradually pressurize the drill bit point into the "to be drilled" material surface. Then, gradually and completely, release that pressure to the point where you can eventually hold the handpiece in just two fingertips with the drill bit point still delicately positioned into the divot that you just created.

Next, delicately regrasp the handpiece in the HDP position, step on the flex shaft's foot pedal—gradually increasing speed and downward pressure on the handpiece—and allow the bit to find its appropriate feed rate as it scrapes a cylindrical path through the material. Practice, practice, practice, and eventually this technique will become second nature!

Drilling on a Curved Surface

Try as you might to employ the methods previously mentioned on a curved surface (tubing, ball or any convex surface), the drill bit point will still want to go dancin' without you. Why? The curved surface further reduces the drill bit point's contact area so you just can't make a good impression in the surface. Solution: make your own point. Let's call this Tomboy's Dimple-matic. Take any ordinary awl point (awls are ancient tools for making holes in stuff), and file the point off at an oblique angle.

The overall length of the tool (the sum of the pointed shaft and the handle) should be such that when the handle base is placed against the palm of the hand, the point of the tool emerges between the forefinger and the thumb not more than $1/2$" (13mm). Depending on the size of your hand, this generally makes the tool length between $3^{1}/_{2}$" and $4^{1}/_{2}$" (9cm and 11cm).

To use this tool to make a divot, place the knuckles of two fingers and thumb tip against the curved metal or other material surface with the point of the tool just emerging from the clutch of the fingers. I position the point of the Dimple-matic against the material and commence a controlled wiggling action, while gradually increasing the pressure, until I see a burr being spun up from the surface of the material to be drilled. Once done, I can place the drill bit point in that divot and proceed with the drillin'.

Sawing and Drilling Practice

Now that you know the basics of what your tools are and the most efficient ways you should use them, it's time to start practicin'!

It's a good idea to go through the exercises on the next several pages before attempting the projects that follow.

For each of the exercises, as well as the projects, you will use a paper pattern (a.k.a., a design template) that you will adhere with rubber cement to the surface to be cut or drilled. These templates are all available for download on my Web site and are easily printed out at the actual size. Alternatively, they have been provided here for you in the book, though you may need to resize them on a copier accordingly.

For any of the sawing and/or drilling exercises that follow, it's a good idea to clean up the surface of the metal sheet—front and back—before you use rubber cement to adhere the design template to the metal sheet. You can use a variety of abrasive solutions for this such as Snap-On sanding discs in your flex-shaft handpiece, 3M scrubby pads, steel wool or sandpaper (120-180 grit).

Sawing Exercise for Metal

In this exercise your mission is to master the sawing out of all elements in the exercise and at the same time respect the integrity of the negative material surrounding the elements. In other words, the negative shapes should be regarded as positive shapes, and all elements regarded as essential to a successful accomplishment of the sawing exercise. This may require you to do this exercise repeatedly until you can produce the final result (see Step 9).

If you follow the numbered progression of shapes in this exercise (as printed on the pattern), they will lead you through a variety of sawing arcs and angles. Use a no. 52 drill bit to drill holes within the small circle at the tops of Items 6, 7, 8, 9 and 12 before you saw those shapes out, and you'll end up with four little charms that could be used in some jewelry application. When you're done, you should be able to fit all of the pieces, which you've precisely cut out, back together to see how good you've gotten in the process.

Want more sawin' practice? Go to thomasmann.com and download the Doggit Sculpture.

WHAT YOU NEED

- 20g or 22g brass or bronze metal sheet, 2" x 3" (5cm x 8cm)
- Sawing Exercise for Metal pattern (page 45)
- rubber cement
- jeweler's saw
- 2/0 saw blades
- drill with no. 52 bit

1 Begin by adhering a copy of the pattern to the metal sheet, using rubber cement, and then sawing out shape no. 1. Using the bottom of the blade, place the blade's smooth area against the work face at the line for the shape and draw your frame downward with NO forward pressure. The saw blade will make its own little starting notch. On the next stroke, add a little forward pressure and you'll be Sawin' Where Y'at!

2 Your first corner turn approaches! Remember, the trick to turn a corner is in the slight backward pressure on the blade from the frame and pivoting the saw blade in place as you notch out clearance for the blade to turn into. (See page 24 for more on Turning a Corner.)

3 Continue through all corners of the shape.

4 Saw out through the edge of the sheet.

5 Continue through shapes number 1–5.

6 Shapes number 6–9 and number 12 are charms. Though it's not pictured here, I recommend that you center punch and drill out the jump ring connection holes at the top of each charm with a no. 52 drill bit before you saw the charms out of the sheet.

7 Continue sawing out the charm series.

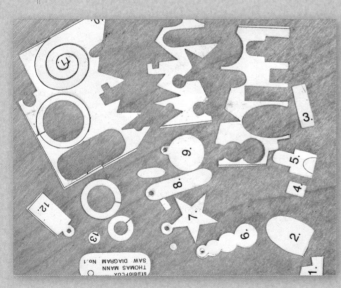

8 If you have been supporting the work face effectively throughout the sawing exercise, all parts—both positive and negative—should be nice and flat.

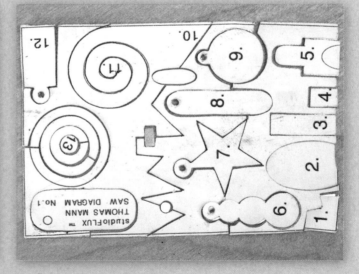

9 When all of the elements are sawn out, they should fit back together like a jigsaw puzzle. When you can achieve this outcome, you'll be ready to move on to more challenging projects.

Sawing Exercise for Plastic

In this exercise your mission is to experience the shift in texture between metal and other materials. You'll also be doing a "piercing" operation. This means removing a shape from the interior of a sheet of material. Third, you'll be sawing a "slot" that must be sawn accurately so the two elements of the finished piece slot together with enough friction to keep the slotted pieces in place.

For slotted sculptures to work, the slots have to be sawn precisely to the dimension of the material that is to be slotted together. I try to saw my slots just slightly shy of the actual dimension so I can adjust them if necessary by using the file capability of the saw blade to "open up" the slot to the perfect dimension. You can remove material, but you can't put it back!

(Note: You can't really check for the perfect fit with either the design diagram or the protective paper still glued to the acrylic surface. So peel them back from the slots area before you test-fit the pieces together.)

WHAT YOU NEED

- 1/16" (2mm) clear acrylic sheet (leave on protective covering)
- Sawing Exercise for Plastic pattern (page 45)
- rubber cement
- jeweler's saw
- 2/0 saw blades
- drill and any small-sized bit

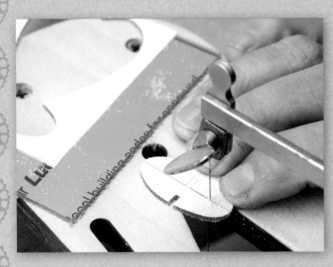

1 Saw out the perimeter of the entire shape, and saw the first slot at the bottom center of the oval shape. (Note: When sawing the slot, err on the inside of the line inside the slot. You can open it up if it's too tight, but you can't make it smaller if it's too wide.) Saw across the dividing line of the oval and then saw out the second slot.

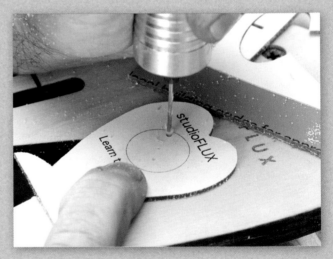

2 Drill a pass hole (any size drill will do) inside the center circle, near the circle line you're going to saw out.

3 Untighten the bottom thumb screw on your saw frame and release the bottom end of the saw blade. Insert the blade through the drilled hole in the center circle.

4 Re-tension the blade as you would when mounting a fresh blade in the frame. (See page 14.)

5 "Pierce" out the circle with your saw.

6 Strip off the pattern and protective coverings from both elements and slot them together.

Sawing Your Signature

This is a true exercise in piercing (see page 23), as all of the sawing you'll be doing is happening in the interior of the metal sheet stock. The trick is to plan for the suspension of negative space in the signature pattern. For instance an "O" cannot be a complete circle, as the negative space within it would fall out. Another little trick is hiding the saw blade insertion point hole by widening the pierced saw line from either side of the drill hole and tapering it to the primary saw line. I saw the initial lines of this signature exercise with a 2/0 blade and later expand the line width with a 1/0 blade.

WHAT YOU NEED

- copy paper
- fine-point permanent marker or writing implement of your choice
- 20g or 22g brass or bronze sheet
- rubber cement
- drill and no. 60 bit
- jeweler's saw
- 2/0 and 1/0 saw blades

1 On a plain sheet of paper practice your signature. You may want to space your lettering a little wider than natural for this exercise.

2 Center punch the starting point of each line.

3 Drill out a hole at the beginning of each line with a no. 60 drill or the smallest drill you have.

4 Pierce out the lines of your signature with a 2/0 blade. Later if you wish to widen the line and soften the insertion point hole into the line, use a no. 1 or 2 blade.

Tube Cutting

All kinds of hand tools have been invented for the jewelry bench that are designed to make the work flow more efficient and less tedious. To one extent or another, they achieve this lofty goal. The tubing cutter jig is one of these. It doesn't cut the tubing for you, but it does standardize the length of the cut, ensures a relatively perpendicular cut and holds the tubing securely in place whilst you saw off the measured section. Put that apron or towel in your lap and you'll be turning out piles of short, hollow round things!

WHAT YOU NEED

- tubing lengths of various ODs and IDs (outside and inside diameters)
- permanent marker
- tubing cutter jig
- jeweler's saw
- 2/0 saw blades

1 Mark the tubing for the desired length and use this mark to set the stop on the tubing cutter jig.

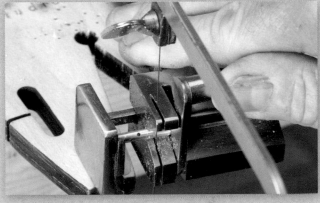

2 Insert a tubing length in the jig and compress the holding arm against the tubing. Insert your saw blade in the alignment slot and saw off a segment.

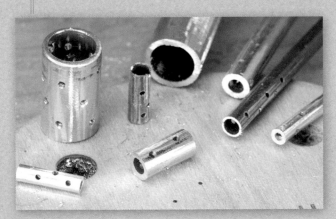

3 I often use sections of tubing with holes drilled randomly about them. I do all of this drilling before I saw off the segments.

Making Jump Rings

I've been making my own jump rings for forty years, and I have to say it is absolutely my least favorite task. As a result, I am always looking for easier, faster ways to accomplish this relatively miserable necessity. We've tried every tool and trick you can imagine. We've used the specialized flexible shaft tools available from jewelry tool supply houses with very mixed results. I find those rotary saws a bit dangerous for anyone other than the highly skilled, very patient user. Inevitably, we revert to tried-and-true methods that, quite frankly, may be tried but are hardly true in that they are not terribly efficient and are rough on your hands. We've sawn 'em from the outside and the inside, from the top and from the bottom of the coil, all to the same challenging and physically tiring end: chasing them around the floor under the bench!

I developed a device I call a Jump Ring Cradle (see step 4) that attaches to the surface of your bench and extends out from the edge. The coil sits securely in a slanted channel and the saw splits the rings from the bottom up. There are other alternatives as well, which you'll see in steps 5 and 6.

WHAT YOU NEED

- wire—any gauge or metal (silver, brass, nickel, copper)
- tapered bezel mandrel or jump ring mandrel
- Jacobs chuck winder or bench vise and C-clamp
- Jump Ring Cradle (see Resources, page 140) or standard bench pin with V- or U-shaped slot stop
- jeweler's saw
- 2/0 saw blades

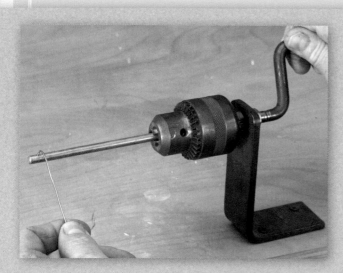

1 The first step to making jump rings is creating a coil from wire. This can be easily done by inserting wire into a jump-ring mandrel that's mounted into a Jacobs chuck winder.

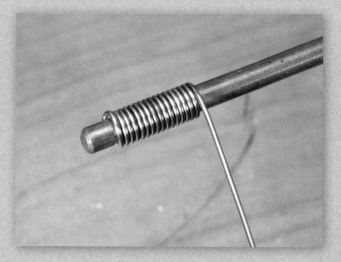

2 The length of the coil is up to you and depends on how many jump rings you want to make.

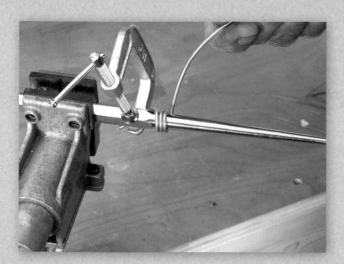

3 An alternative to making your coil on a jump ring mandrel in a bench-mounted winder would be to coil the wire by hand around a mandrel or to use jump ring pliers.

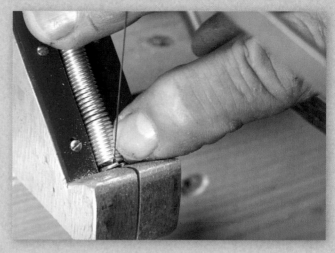

4 Set your coil into the Jump Ring Cradle and begin sawing the individual rings apart from the bottom.

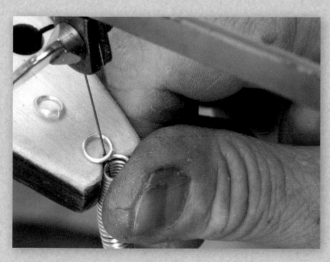

5 Another option: Thread the saw blade through the coil and saw from the inside out, starting at the top of the coil and securing the coil against the bench pin. My bench pin has a little recessed area that works well for this.

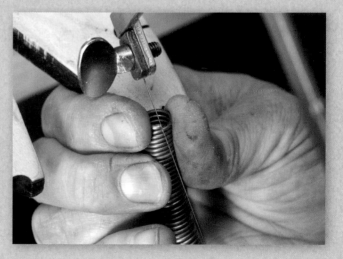

6 Finally, a third option is to hand hold the coil against the bench pin and saw the rings apart from the outside of the coil inward.

Drill Bit Index

My dad, who was a professional machinist, introduced my brother and me to drill bit indexes. Initially—much to his chagrin—we viewed them as toys! Eventually, he took to hiding them from us because we'd raid them for bits, then lose them or leave them out in the rain to rust, rendering his set missing critical sizes. I have become fanatical about replacing bits after use in my own indexes, remembering his rage at our antics, so that I always have a complete set when the right bit size is required.

If your method of working requires a particular range of bit sizes that you use repeatedly, it might be beneficial for you to fabricate your own specialized drill bit index. Here you can store a supply of bits specific to the range of tasks required. Also, as with all well-made indexes, you can use them to size rod stock for the exact drill bit mate size by trial insertions into the index's drill slots. This makes for a great fabrication exercise in precision fitting and results in a truly useful tool on your bench.

WHAT YOU NEED

- Drill Bit Index patterns (page 45)
- rubber cement
- 20g brass or bronze sheet
- jeweler's saw
- 2/0 saw blades
- drill with bits:
 - ⅛" (3mm)
 - ¹⁄₁₆" (2mm)
 - no. 65
 - no. 60
 - no. 55
 - no. 52
 - no. 48
- ⅛" x 2" (3mm x 51mm) machine bolts with nuts and washers, 4
- ½" (13mm) brass or aluminum tubing (⅛" [3mm] ID) or nylon spacers, 4pcs
- sanding wheel
- files

1 Lay out a pattern for your index or use the template provided. There are three levels to the index. Paste the patterns onto the metal sheet.

2 Saw out the basic shapes. Then center punch all of the drill point penetrations.

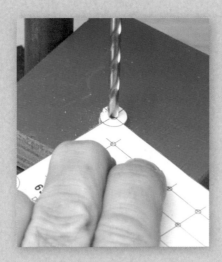

3 Align and stack the three panels and, keeping them held together, drill one ¹/₁₆" (2mm) hole in one of the corners. Insert a ¹/₁₆" (2mm) bolt and spin on a nut. Now drill a same-size hole in the opposite corner. Tighten on a second bolt. Finally, drill the remaining two holes.

 Note: When precision alignment is called for, I use a drill press. It could be a traditional benchtop drill press or, as pictured, a flexible shaft, handpiece adaptor drill press.

4 Remove two of the bolts—in opposing corners—and drill ¹/₈" (3mm), opening up the ¹/₁₆" (2mm) holes.

5 Insert ¹/₈" x 2" (3mm x 51mm) machine bolts into these holes, tighen on a couple of nuts, then drill ¹/₈" (3mm) holes at the remaining two corners after removing the smaller bolts.

6 Separate the three-layer package and reassemble with the top two layers only. Drill out each row with the designated drill no. size through both layers.

7 Scribe the bit nos. onto the face of the metal so you'll always know at a glance what the sizes are.

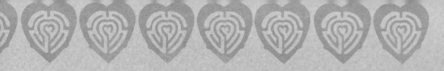

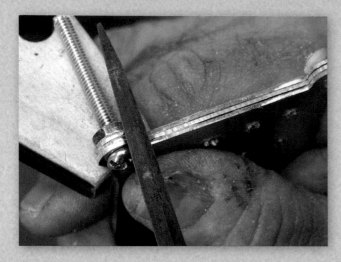

8 Reassemble the stack to include the solid bottom layer and file the corners together as a sandwich.

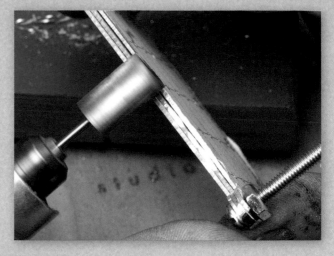

9 Using a sanding wheel or a file, clean up the edges of the sandwich as well.

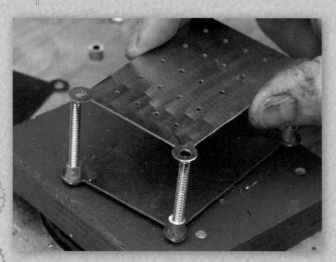

10 Disassemble again and reassemble all the layers inserting tubing pieces or nylon spacers between the layers.

11 Spin on four nuts and you've got yourself a drill index/storage rack!

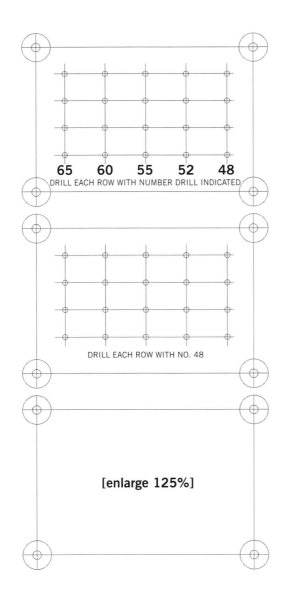

65 60 55 52 48
DRILL EACH ROW WITH NUMBER DRILL INDICATED

DRILL EACH ROW WITH NO. 48

[enlarge 125%]

Drill Bit Index

Sawing Exercise for Metal

Sawing Exercise for Plastic

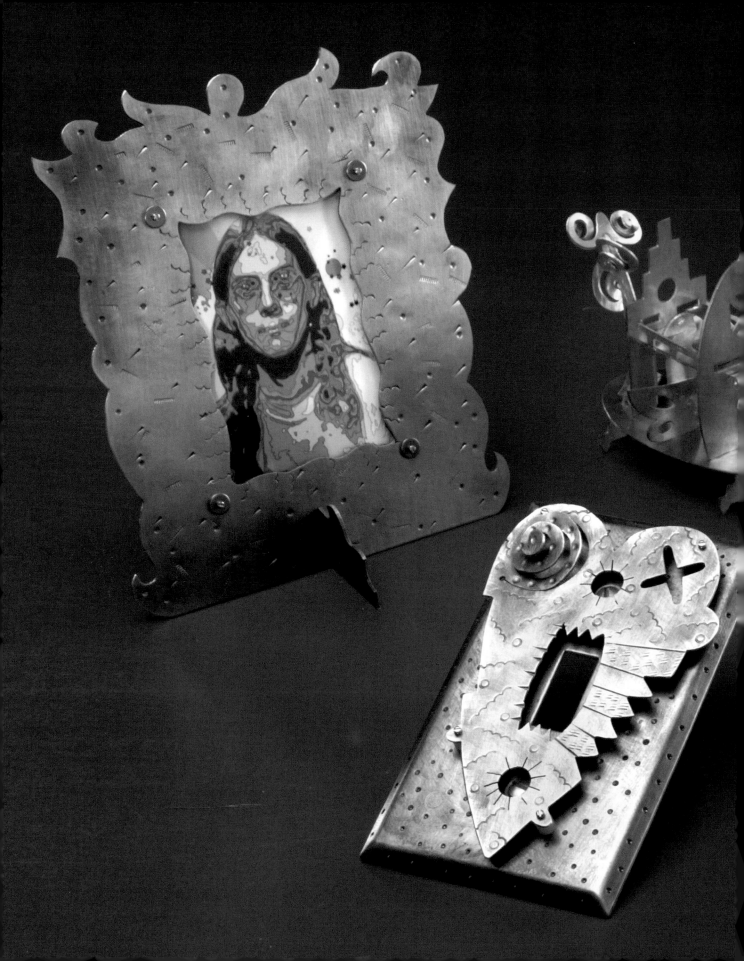

PART TWO: The Projects

So you've been diligently practicing the exercises at the end of Part I, right? And you're Sawn' Where Y'at At and have mastered the SawFiling technique—great! Now you're ready to take on the projects to follow.

These projects are orchestrated from some basic tasks to some that are a bit more complicated. In every case, they are designed to stretch your skill set and your thinking about how things come together.

Behind every great design there is great engineering. I have designed all of these projects to deliver an engineering perspective while at the same time giving the practitioner a new and exciting "way in."

Extreme Paper Dolls, Peg-Leg Slot Sculpture and Funny Money are built for fun! Light Switch Plate, Cake Stencil, Personal Design Template, Photo Frame, Calder Spoons and Jigsaw Monoprint are designed to produce useful objects in the end. Little City may give you fits but will introduce you to slots and

tabs as cold-connection solutions in a big way. How 'bout some jewelry already? OK! Octagonal Slot Heart Pendant, Maze Pendant, Chef's Knife Pendant, Self-Portrait Pin and Cigar Box should keep you busy for a time!

Throughout this projects section of the book, you'll see the work and bench pins of several contributing artists from around the US, Mexico and Canada. You'll note the wide variety of bench-pin personalities portrayed here and the incredible variety of fabulous work that was produced using them. In many cases they clearly depict an adaptation to inefficiency. They are seriously sculpted and worn away but still, the artist has been able to adapt to the changing structure of the pin to saw out their work as precisely as required. These artists have all made a GOOD SAWIN' adaptation to the whimsical character of their bench pin.

Have fun, be happy, don't worry and make some good stuff!

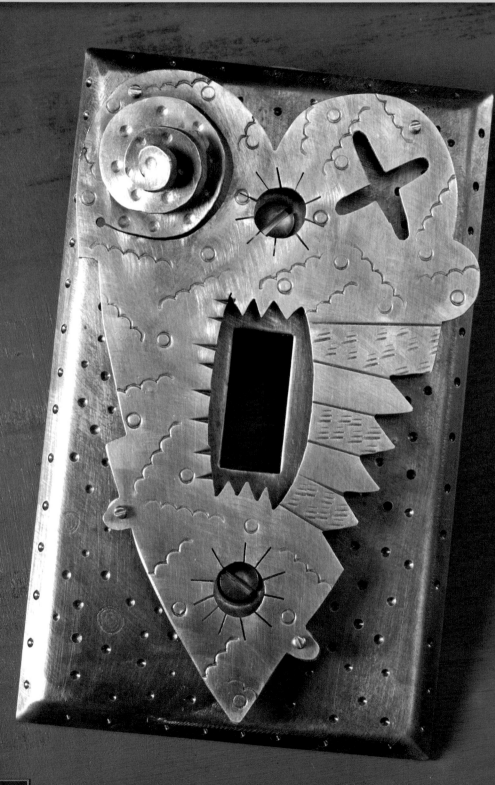

I n addition to the sawing that's required for this project, you'll also be challenged to apply a surface texture to the floating plate element and to the switch box cover plate. You might choose to *chase** a design into those surfaces, chemically or electrically etch them, or seriously pierce at least the top floating plate. This one is pretty wide open to your thematic inclinations. You can use the design provided or come up with your own.

CHASING is a technique similar to embossing leatherwork. Chisels, punches, etc., and specially designed decorative chasing tools are hammer driven, on a steel block into the metal surface, leaving their particular shape in the metal. Chasing is also a forming process because you're not removing metal, you are moving metal. When metal at the chasing site is displaced, it moves out of the way of the tool's face to the sides.

WHAT YOU NEED

- copy of Light Switch Plate pattern (page 138) and rubber cement
- 16g metal sheet (your choice)
- commercial light switch plate (metal)
- jeweler's saw
- 2/0 saw blades
- bench pin
- drill with no. 52 bit and etching bit
- hammer
- chasing tools
- steel bench block
- sanding disc
- file
- blackening solution and brush
- steel wool
- paper towel
- 080 micro bolts and nuts
- nylon spacers (to fit bolts)
- flush cutters

1 Paste the heart template onto the metal sheet.

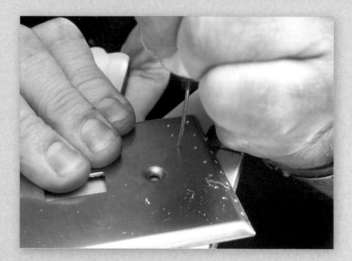

2 Use the drill to create divots on the surface of the commercial plate. Try not to drill all the way through the plate. A drill press makes this job a bit easier because you can set the depth.

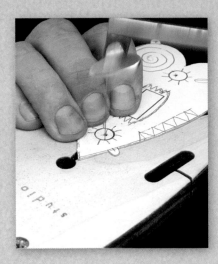

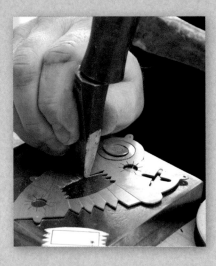

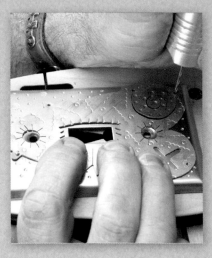

3 Saw out the exterior heart shape and then pierce (cut out, remember?) the interior negative shapes.

4 Create lines and texture on the heart using chasing tools.

5 With a no. 52 drill, make holes in the heart at designated spots. Use the heart as a template to then drill corresponding holes into the switch plate.

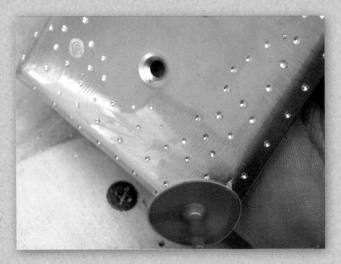

6 Apply texture to the surface of the plate using a sanding disc.

7 Also apply texture to the heart. This can be accomplished with a file as well.

8 Brush blackening solution onto the heart and the plate.

9 Use steel wool to polish the heart and the plate.

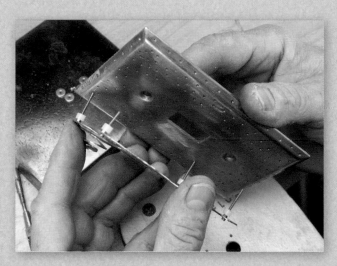

10 Insert 080 bolts through the no. 52 holes in the heart. Spin on the nuts and then add a nylon or similar spacer to each bolt. Thread the bolts through the plate from the front to the back.

11 Spin nuts onto the bolts at the back of the plate and trim the excess bolt lengths with flush cutters.

ow I never did this as a kid—way too girlie!—but I do recall making certain holiday shrubbery decorations that echoed this technique. Jump to now: As another demonstration of the incredible capability of the jeweler's saw, I started experimenting with this thing and actually got pretty excited about it. You can fold cover stock—ten to fifteen thicknesses—draw an intricate design on the top layer, connecting the edges at the folds, saw it all out and when you pull it open . . . wow! Think of the possibilities for this!

WHAT YOU NEED

- ruler (I prefer C-thru grid rulers)
- pencil
- 80-lb. cover stock
- scoring tool
- drill with no. 52 (or similar small) bit
- jeweler's saw
- 2/0 saw blades
- bench pin

1 Mark off a sheet of cover stock in 1½" or 2" (4cm or 5cm) increments.

2 Score the increments with a blunt scribing tool. I'm using a fine-point nylon scoring tool here, but sometimes I use a dried-out ball-point pen for this.

3 Accordion fold the scored piece of cover stock.

4 Draw your design onto one fold, making sure to allow connection points on both edges.

5 Drill saw blade penetration points in the negative spaces then pierce out the design on your bench pin.

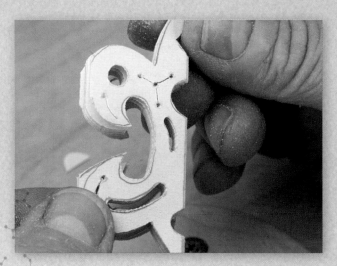

6 The extracted shape.

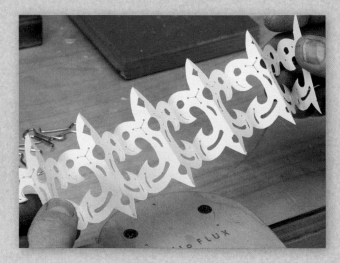

7 The unfolded design.

Metal Artist BENCH PIN

Robert Dancik

The Map is Not the Territory

OF ALL THE TOOLS THAT COME TO BEAR THEIR MARKS on my work, my jeweler's saw is the one that exerts the most influence on what I make. My saw has truly become an extension of my hand and I am as comfortable using it on various materials as I am employing my knife and fork to eat.

The soul mate of my saw is my bench pin. When I sit at my bench to work, it is the constant and unconditionally supportive conversation between the two that allows me to render the forms I need and want. There is hardly any flat surface left and I fear the day that any big chunk decides to call it quits under the pressure that I place upon it daily.

Both these loyal tools have served me well and every piece I make reminds me that I owe them more than thanks for putting up with the use and abuse I put them through.

www.fauxbone.com

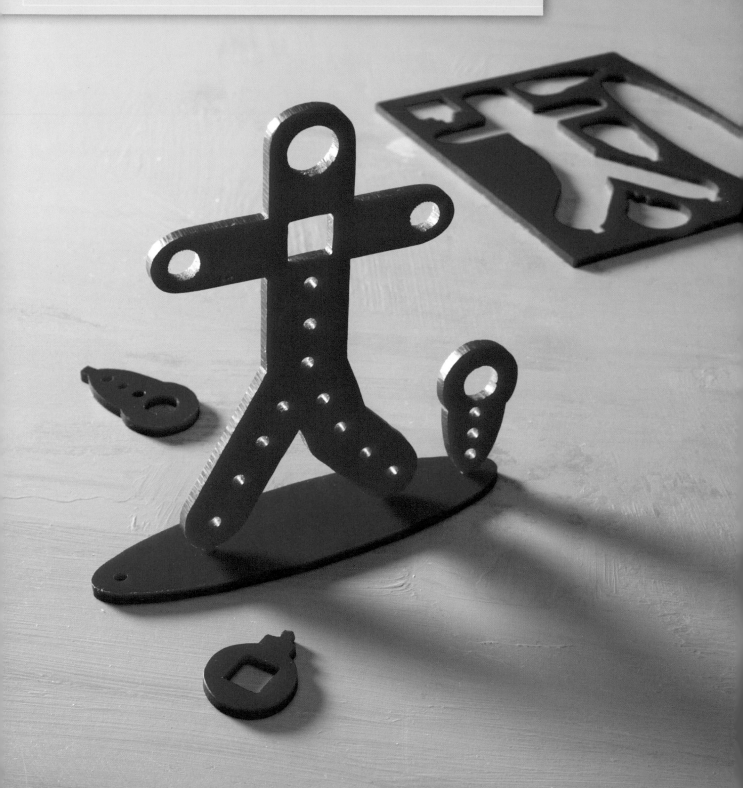

This project is a variation on the Sawing Exercise for Plastic on page 36. Instead of slots, we have pegs, and instead of using ¹⁄₁₆" (2mm) acrylic, we'll use ⅛" (3mm). You can use a standard 2/0 blade for this. And you'll need a ⅛" (3mm) drill bit to drill the peg holes.

In need of an aggressive challenge? You could try enlarging the pattern 200% and pasting it up on ¼" (6mm) acrylic. In that case, you'll want to use a skip-tooth blade.

WHAT YOU NEED

- Peg-Leg Slot Sculpture pattern (page 139) and rubber cement
- ⅛" (3mm) acrylic sheet (any color, including clear), 4" x 6" (10cm x 15cm)
- drill with nos. ⅛" (3mm) and ³⁄₁₆" (5mm) bits
- jeweler's saw
- 2/0 saw blades
- bench pin
- file

1 Paste the template onto a ⅛" (3mm) acrylic sheet of any color—I'm just partial to red!

2 Drill saw blade insertion start holes at the points indicated on the plan, using a ⅛" (3mm) bit. At the same time, drill pilot holes in the center of all of the other design holes in the sculpture.

3 Then drill the design holes (not the blade insertion holes) out with a ³⁄₁₆" (5mm) drill bit. You can use your flex-shaft handpiece for this if you're confident; otherwise use your drill press. Insert a 2/0 blade and start sawing. Note: Acrylic sheet will vary in density relative to the color pigment used in its casting. You may want to switch to a lower TPI blade. (See TPI, page 15.)

4 When all of the parts have been carefully extracted from the sheet, they should all fit nicely back in the parent sheet.

5 The square pegs on the ends of the legs of the little man and on the stand-up sculpture pieces have to have their corners carefully filed off and rounded to fit the round holes in the base. File a bit, test the fit, and then file some more.

6 Assemble your sculpture, using the side pieces to suit your mood.

Metal Artist BENCH PIN

Jill Marie Shulse

Tree of Life

I LOVE TO SAW. WHEN I'M SAWING AND REALLY GET 'TUNED-IN' TO WHAT I'M working on, time just seems to stand still and I become oblivious to anything else going on around me. I find sawing to be a very meditative and calming experience.

I got the bench pin that I'm now using about 4 years ago, so it doesn't have a lot of 'war wounds' yet. I love the unique design of it, and use it as a support surface when I file metal as well as the place where I do all my sawing.

www.jillmarieshulse.blogspot.com

Natalie Nichols

I NEED MY BENCH PIN FRESH, FLAT AND LEVEL BECAUSE OF the of type sawing I do. Keeping it level ensures that I can maintain fine detail in my work without breaking too many blades.

www.natalienichols.net

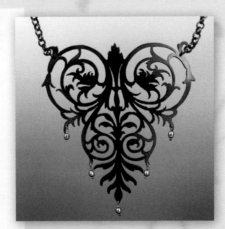

Floral Heart Necklace

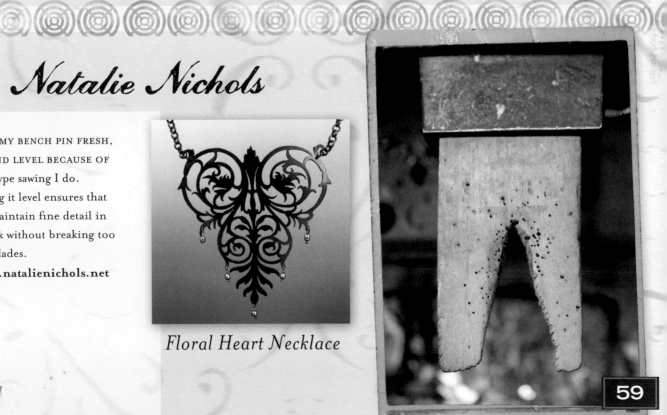

Have you seen those coins at the flea markets that guys have sawn out and turned into necklace charms and key rings? Some of them really know what GOOD sawin' is! Well now it's time for you to try this. See how inventive you can be! Saw up some of your own Funny Money and then go pay for stuff with it. Just wait till you see how people react to this creative little art event. I have regularly been able to increase the value of a quarter to a dollar when some enraptured clerk just has to have that Funny Money! Of course, the time you put into doing this is probably worth way more than seventy-five cents, but I guarantee you'll have some fun.

WHAT YOU NEED

- Yer' gonna need some money! (coins)
- fine-point permanent marker
- center punch
- drill with nos. 65, 60, 55 and 52 bits
- jeweler's saw
- 2/0 saw blades
- bench pin

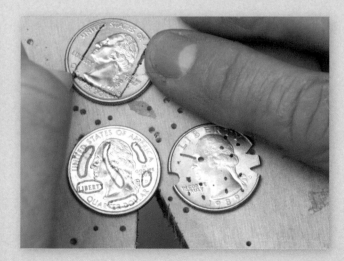

1 Have fun altering your coin stash. I drew what I wanted to saw out directly on the coins with a fine-point permanent marker.

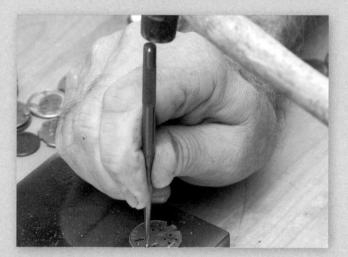

2 Center punch in the negative spaces where you want to drill and then pierce.

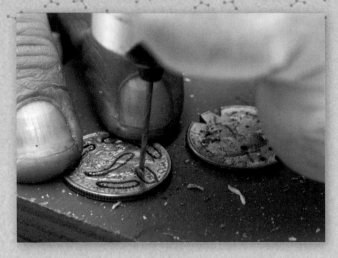

3 Drill at the center-punched marks.

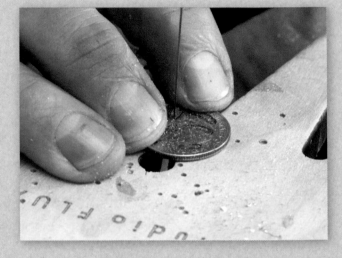

4 Insert your saw blade and pierce out the shapes.

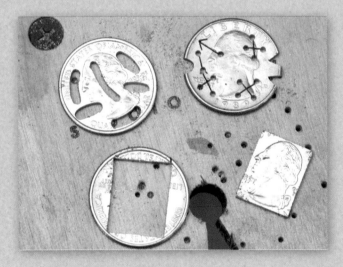

5 *Voilà!* Funny money.

Metal Artist BENCH PIN

Keith Lo Bue

Wrecked

My bench pin gestures out from my bench—an open hand— rock-solid to cradle my work and my tools. It takes so much abuse, and it accumulates filings in its pores, but the offering hand remains.

Its beauty increases in my eyes as the pin slowly splinters and disintegrates until it reaches the stage where its utility is compromised. At that point it graduates and is made into a wearable object, and only then will it be treated with kid gloves. How wonderful that I can spend years seasoning each pin, patiently watching it gather its own history.

www.lobue-art.com

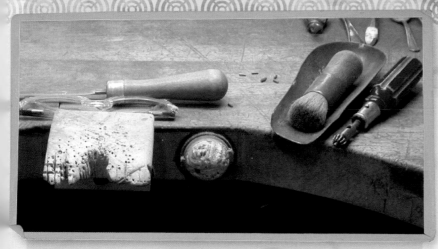

Square "De-SIGN" Series, D.P.W. Brooch

Boris Bally

I have been using the same jeweler's saw since 1974. It is the first one I purchased. It also came with me when I went to Switzerland to learn how to use it, during my apprenticeship. It is one of my favorite tools as it is the sole reason why I am a metalsmith. When I saw my teacher Steve Korpa using a jeweler's saw, I was AMAZED that a small blade like that could cut through metal like butter.

My bench pin was designed by my friend, Chris Darway and is very special to me. I often use it as a tube-cutting, wire-cutting, sawing and filing jig. It easily becomes transformed by filing the wood to create whatever form I need to support the task of the moment.

www.borisbally.com

Just to prove it can be done! Create an intricate design in a hemisphere of a 9" (23cm) diameter. Draw it by hand or computer-aided. Print it out or copy it. Next, fold a piece of letter-size, 80-lb. cover stock in half vertically. Rubber cement the equator line of your hemisphere design to the folded edge of the cover stock. Insert a sheet of clean copy paper, folded in half to match, inside the cover stock. Staple around the edges a couple of times. Drill holes in the negative spaces—yes, drill 'em— then insert and string up your saw blade into those holes and pierce out the design. When complete, slip the copy paper out from the sandwich, lay it flat out and centered on top of your 9" (23cm) red velvet cake and shake powdered sugar all over it. *Voilà!* The saw performs for the baker!

1 Draw as intricate a pattern as you can inside a 9" (23cm) half circle. I did mine in a drawing program on the computer, but any method will work. Fold a letter-size sheet of cover stock in half. Apply rubber cement to the back of your half-circle design, and align the straight portion against the folded edge of the cover stock. Fold a second sheet of copy paper in half and insert it inside the cardstock. The cover stock imparts a little more stability to the sawing environment.

2 Drill—yes, drill—holes in all of the negative spaces in your design. Cut out all of the negative spaces by stringing your saw blade through each drilled hole.

65

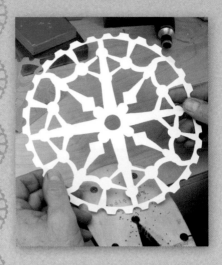

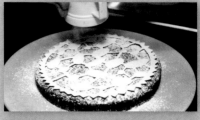

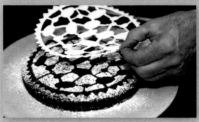

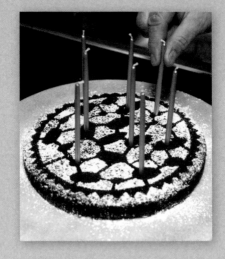

3 When you are done sawing, extract your sawn pattern from inside the folded cover stock and unfold.

4 Center your pattern on a 9" (23cm) (red velvet!) cake top and sprinkle with powdered sugar. *Voilà!*

5 Insert the birthday candles and celebrate!

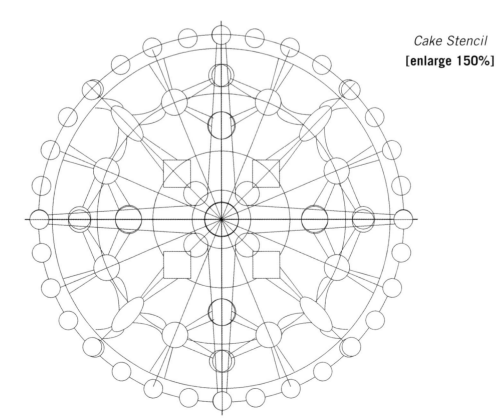

Cake Stencil
[enlarge 150%]

Metal Artist Bench Pin

Abigail Heuss

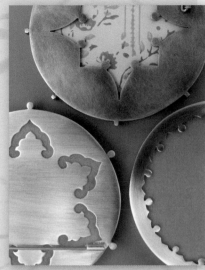

Home / Away from Home Brooches from the Distance Series

Sawing is tricky and frustrating at the start, but once you get the hang of it it's just like a drawing tool. My saw blade is like a fine pen. Its marks are crisp, permanent and exactly as confident or hesitant as I'm feeling at the time.

Bench pins are beautiful illustrations of body mechanics. You can tell which hand the owner favors, what tools they use, what kind of work they do and how they do it. The marks on my bench pin will tell you that I am right-handed and I do a lot of piercing. I prefer hand tools to machines and I am precise but heavy-handed.

www.AbigailHeuss.com

Abrasha

The custom bench pins in my shop are maple and are made to fit into my bench so that the top of the pin sits below the top of the bench instead of flush with the top of the bench. That way, while I am sawing or filing, or when I brush filings off the pin, filings fall into the filings tray instead of ending up all over the top of the bench. The only thing I do to them after they are installed in my bench is to file an angle onto the front of the pin and a few small notches into the front, to hold work against securely. That is all. The pins I have in my benches now have been there since 1989 and may not need to be replaced for at least twenty-two years more.

www.abrasha.com

Washer Ring with Diamonds

PERSONAL DESIGN TEMPLATE

Do you have a chop or logo that you use to sign work or place next to your signature on letters? Do you have certain symbols, letters or other design shapes you use repeatedly in designing your work? Well, maybe you'd find a personal design template useful. I've been intrigued with making my own templates since I was a kid. I have file folders full of them in a cabinet next to my drawing board. I still use them regularly, even though I use the computer to design also.

How the template will be used can determine the material you cut it out of. Mostly I'm making them from transparent or translucent plastics, because positioning them is facilitated when you can see through them. But a template that might be used to guide a cutting tool, such as a mat knife, would best be made of metal.

When the template calls for alignment marks or measurements, print the design out, or copy it onto a clear sheet of label stock. Then peel the back off and lay it down on a prepared sheet of material and saw it out like you would if you were sawing out a paper pattern. Just don't pull the design off afterward. On some of these templates, I also include outside corner radii in different dimensions.

WHAT YOU NEED

- ¹⁄₁₆" (2mm) clear acrylic sheet, whatever size suits your design
- copy paper or clear label stock and rubber cement
- pencil
- drill with no. 52 bit
- jeweler's saw
- 2/0 saw blades
- bench pin

0.25" RADIUS 0.5" RADIUS

1" RADIUS

0.75" RADIUS

Personal Design Template
[enlarge 133%]

1 Sort through your favorite design icons and refine them into fairly precise line drawings. Lay them out in an orchestrated, closely aligned arrangement. I use a light box for this or, if you have the chops, a computer design program such as Adobe Illustrator. When using the computer, scan in your drawing, copy out the individual design components, size them incrementally, nest them together on a blank page, type in dimensions if you wish and you're good to go!

2 Make a copy, or print out a page, trim it up and paste it up with rubber cement onto whatever material is appropriate—acrylic or metal—depending on how the template will be used.

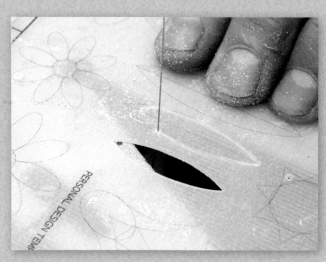

3 Drill saw blade insertion holes and then saw it out!

4 Go use it!

Metal Artist BENCH PIN

Diane Falkenhagen

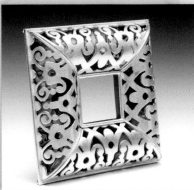

Double Hidden Portrait

I RECENTLY BOUGHT A BRAND NEW SAW FRAME—PRETTY AND RED AND very hi-tech looking! I began to use the new, fancy one with joy. But it was no time at all before I was longing for the old one again. Luckily I had not thrown it away. There is just something compellingly familiar and comforting in one's old saw.

Although I have more than one bench pin, my favorite is one that my father made me when I first started making jewelry as a teenager. There is definitely a sentimental attachment, but also, it is very functional!

www.dianefalkenhagen.com

Marjorie Simon

Large Blossfeldt Oval Neckpiece

MY HANDSAW IS MY ALLY IN THE STUDIO. I LOVE TO SAW, AND I AM relaxed and confident working my saw around the most intricate designs. Although I use the KnewConcepts saw for most jobs now, for decades I relied on the conventional 4" jeweler's saw, with occasional use of the deep-throated frame.

I have a number of customized bench pins for different jobs, including a skinny one for jump rings, but after studying with Klaus Burgel, who was trained in Germany, I've gotten into the habit of using a solid bench pin without a V-cut and customizing it as I go. I like the support it gives me and the work.

www.marjoriesimon.com

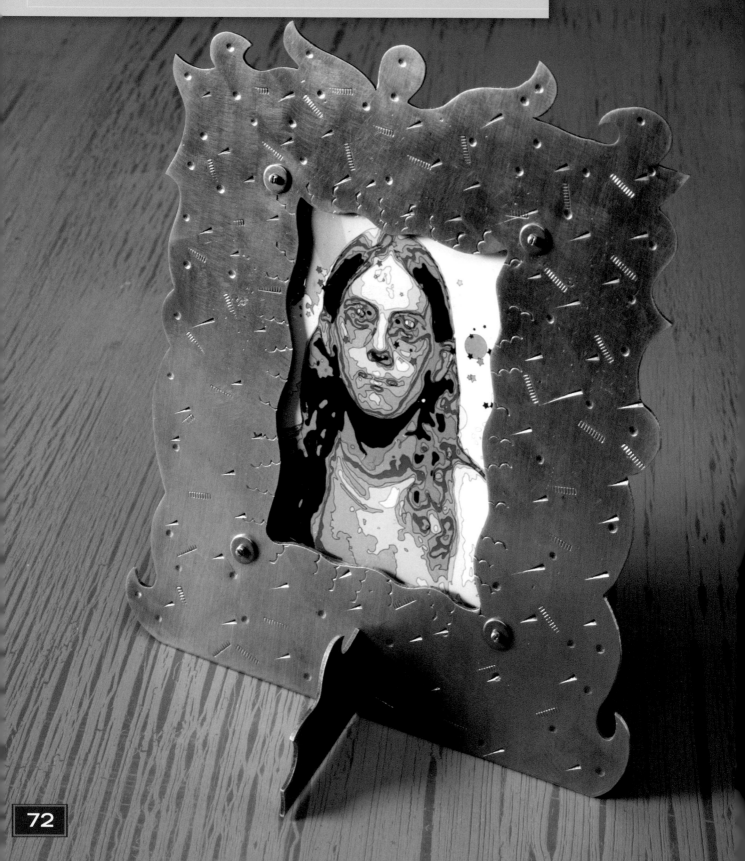

This project really offers you the opportunity to make it your own! You are provided with the basic frame plan, but I encourage you to invent your own frame design based on it. Go wild! Have fun! If you have a special or favorite photograph—as we all do—it deserves a very special frame to celebrate its importance. This is a relatively straight-forward sawing assignment. Lots of straight lines here. But you can break out of all this straightness and put a creative spin on the deal by creating an exterior profile for your frame that might be thematic to the photograph's subject.

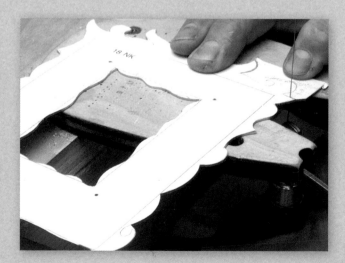

1 Using rubber cement, paste your photo frame design onto your chosen sheet metal. Then saw it all out.

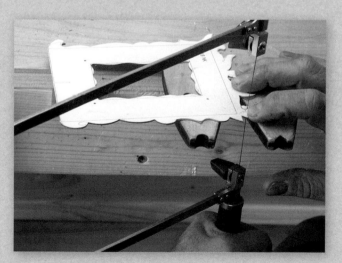

2 In most cases you will need a deeper-throated saw frame to get around the larger metal sheet area.

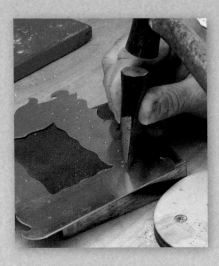

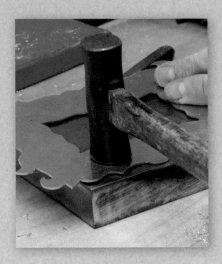

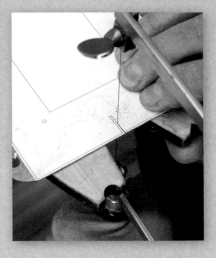

3 I have chosen to chase a design pattern into the surface of the frame, and you may wish to do this also. Alternatively, you could etch in a design—chemically (with a paint pen resist and ferric chloride) or mechanically (with a vibratory etching tool).

4 If you chase your frame façade, be aware that chasing moves metal. Likely you'll have to flatten the façade by "planishing" it with the belly face of a planishing hammer on your steel bench block.

5 Adhere the basic frame façade template over your frame and carefully saw out the frame foot slot.

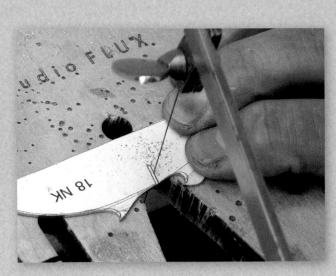

6 When you're done with the frame façade, adhere the stand or "foot" pattern to your chosen metal and saw it out. Remember, you can play off of the basic design here too and put your own spin on it.

7 Next you'll have to fabricate the photo mounting slot package. You must saw out three layers—the frame lens and the gusset (also clear acrylic) and the backplate (I am using textured 22g aluminum sheet from my hardware megamart).

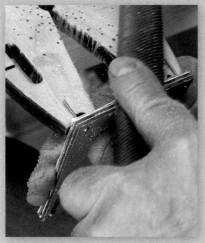

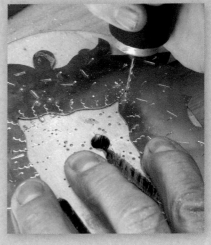

8 Using the backplate as a template, drill two no. 52 pass holes in two opposing corners at the indicated spots. Insert two temporary rivets, fold them over, and then drill the remaining two pass holes.

9 Keeping the pieces stacked in a sandwich, finish the package edges with a combination of rotary files or hand files. Remove the temporary rivets.

10 Drill out the façade's photo slot package mounting holes with a no. 52 drill, using the backplate of the frame package as a guide for the holes to ensure proper alignment.

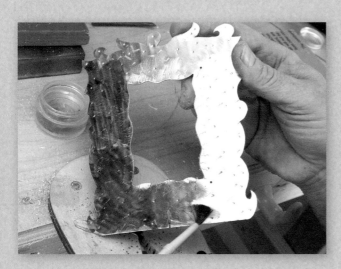

11 Surface finish the façade as you care to. Here, I used a snap-on sanding disc to impart a sanded pattern and patinated the surface with silver blackener.

12 Then either use steel wool or a scrubby pad to polish the metal and impart a nice finish with recessed areas darkened.

13 Strip off the protective coverings from the acrylic pieces of the photo mounting package if you haven't already and then position the lens against the back of the façade, followed by the gusset and then the backplate.

14 Insert 080 bolts and washers through the front of the façade to the back and spin on 080 nuts.

Need a Realignment?

If you encounter any misalignment in the several layers the bolts must pass through, you can run the no. 52 drill through all four layers and get them aligned.

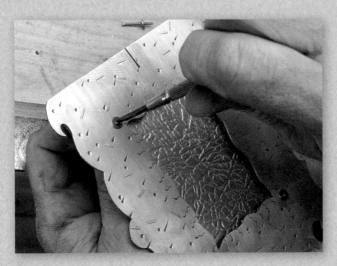

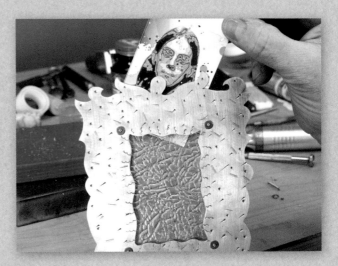

15 Trim off the remaining bolt length with flush cutters and file off the nib. Then tighten all the nuts to snug.

16 Insert your photo in the slot you've created and enjoy!

Metal Artist BENCH PIN

Tim McCreight

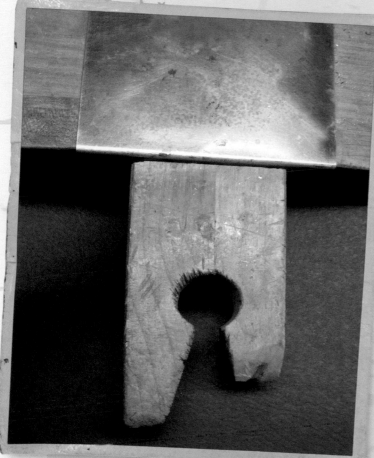

I THINK OF THE BENCH PIN LIKE AN OLD PAIR OF JEANS or sneakers—something that takes a long time to get the way you want it, and a treasure to be preserved as long as possible when it gets there.

With this in mind, bench pins become particularly significant reminders of the people who have used them, carrying as they do the angles, the efforts, and in some cases, the sweat of the artists for whom the pin was the focal point of untold hours of labor.

www.brynmorgen.com

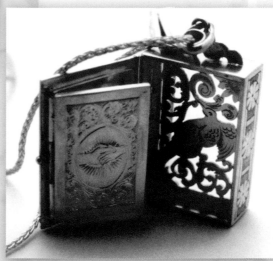

Untitled

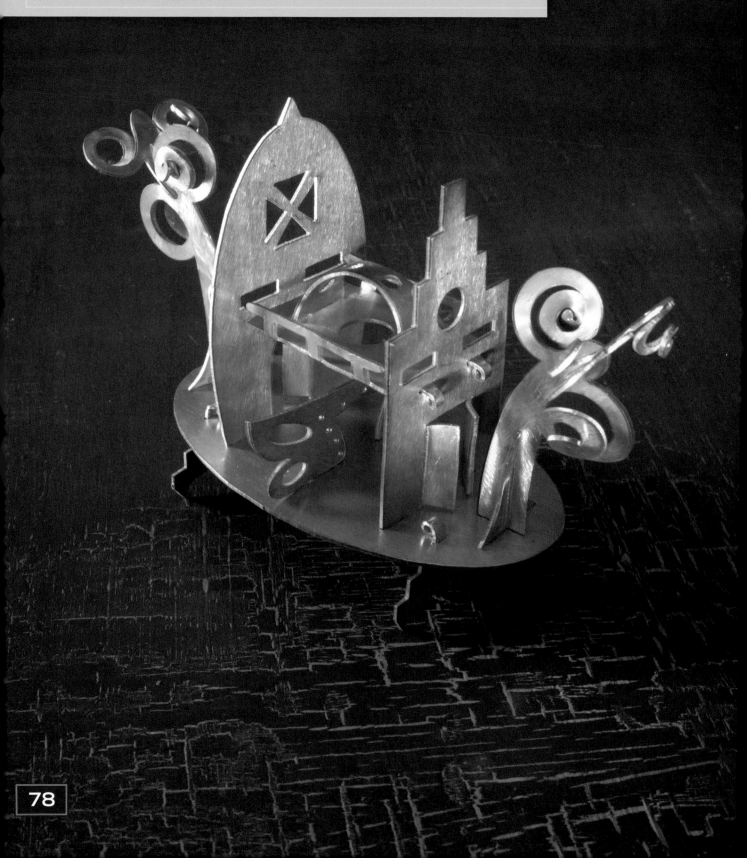

Expertly saw out all of the components here, making sure to "pierce out" the slots in the façades and the base as precisely as you can. The integrity of the final sculpture is dependent on a tight fit at these points. The tabs, or tongues, can be adjusted as necessary by filing them down in order to fit through their partnered slots, so it's better if they're a little larger so you can file them back to a precise fit. To assemble this project, you'll need three pliers: a round/flat-nose, a flat-nose and a needle-nose. I like the round/flat-nose because it places a curved face against a flat one. It only puts an indentation on one side of the work—in this case the tab—and that indentation will be hidden in the curled tab closure. The flat-nose will be used to bend the fins of the standard tab and the needle-nose works well to curl small tabs.

WHAT YOU NEED

- Little City pattern (page 139) and rubber cement
- 22g brass, bronze or nickel sheet, 6" x 8" (15cm x 20cm)
- drill with no. 60 bit
- jeweler's saw
- 2/0 saw blades
- bench pin
- inverted cone burr or triangular needle file
- pliers: flat-nose, round/flat-nose, needle-nose

1 Using rubber cement, paste the Little City pattern onto the metal sheet. Then center punch the areas where you'll need to drill insertion holes for your saw.

2 Drill holes at each of the center-punched marks, and then saw out all of the parts.

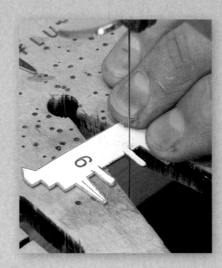
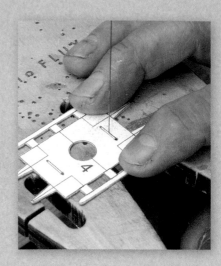

3 It is best to saw the areas marked for slots while still attached to the parent material because you'll have more support. However, sometimes you will find it easier to go back and cut them out of the individual shapes after the fact.

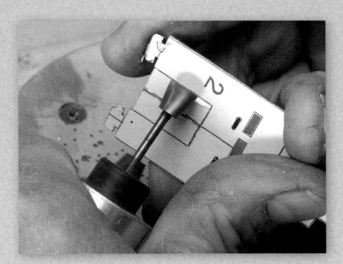

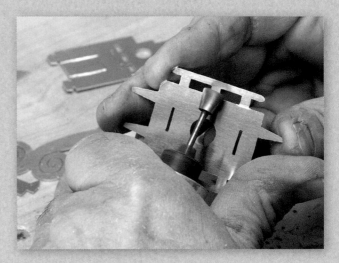

4 Using an inverted cone burr, score a groove in the doorframe lines. This will allow for easy bending of the doors into their final open positions.

5 Once all the pieces are cut out, de-burr all edges using files or cylinder burrs. Use the inverted cone burr to score lines at the points where the railings of the platform will be bent.

6 After relieving the base columns with the inverted cone burr on the platform component, use flat- or needlenose pliers to gently bend the railings vertical and perpendicular to the platform floor.

7 Continue processing all parts for final assembly, scoring additional lines where they're needed, using the lines on the template for reference. When folding the doors open, leave them at about a 45° angle.

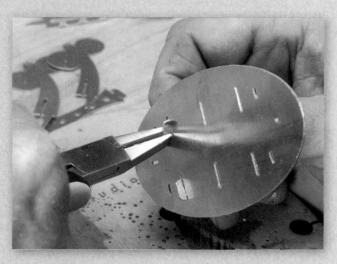

8 Insert the legs of the first façade element through the floor of the primary base platform.

9 Where façade tabs emerge through the primary base, use your flat-nose pliers to bend the tab's fingers in opposite directions, tightening them against the primary base's subsurface.

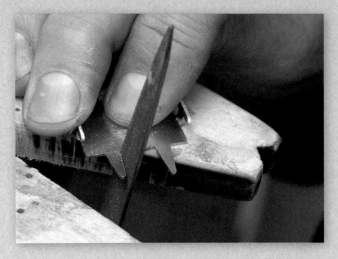 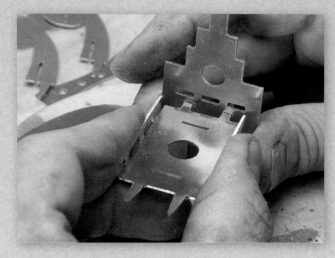

10 At any point during assembly, you may find you need to file the curling tab fingers a bit to get them to conform to the various slot widths.

11 Insert the platform curling tab fingers through the appropriate façade slots.

12 Curl the finger tabs in and against the façade face.

13 Then continue the process with the opposing façade. With round/flat-nose nose pliers, gently curve the arch element into its appropriate form.

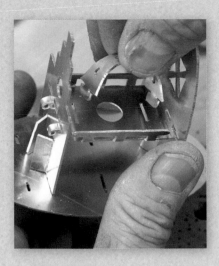

14 Insert the arch element into the platform base slots.

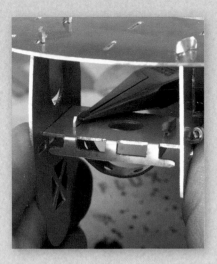

15 Gently bend its tab fingers in opposite directions.

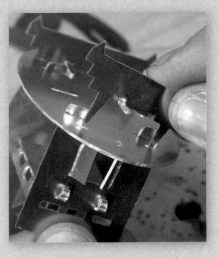

16 Insert the Stand Up leg elements through their finger tab slots in the base.

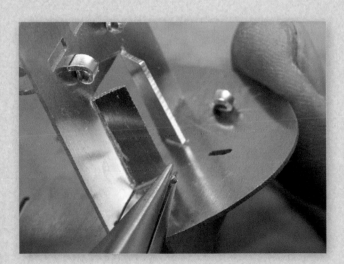

17 Gently curl the fingers back on the upper surface of the primary baseplate.

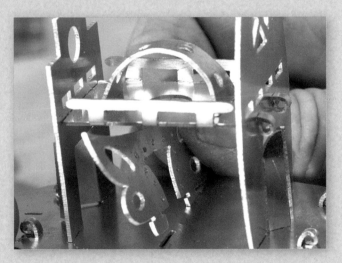

18 Insert the room divider tabs through the slots in the primary baseplate, and gently bend its tab fingers in opposite directions against the subsurface (the underside) of the plate.

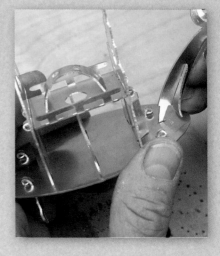

19 Using needle-nose pliers, gently coax the curled coil of the Palm Tree elements out into a 3-D configuration.

20 Insert a slotted Tree Trunk Base into each Palm Tree.

21 Insert each completed Palm Tree into the primary base-plate at opposite ends on the platform.

22 Curl their finger tabs in and against the underside subsurface of the primary plate.

23 Manually adjust any of the pieces as needed.

Metal Artist BENCH PIN

Natasha Wozniak

THE JEWELER'S SAW IS ONE OF MY FAVORITE TOOLS. IT CANNOT BE USED with partial attention, so it is the tool that brings me to my most calm and attentive state. Even though it is the first thing that most beginning jewelry students learn, it is one of the skills that needs to be continuously practiced and improved. These days, I keep two saws ready to use: 3/0 for cutting through thicker stock and wires but mostly 6/0, because I love the precision.

My bench pin always needs breaking in and I put my own angled slots in it for filing. In order to spare my fingers, I always let the sawblade cut into the bench pin at the end of a cut. I am right handed, so that means that the left side of the bench pin eventually gets shorn off by the accumulation of these cuts.

www.natashajewelry.com

Wrought Inlay
Bimetal Cuff

85

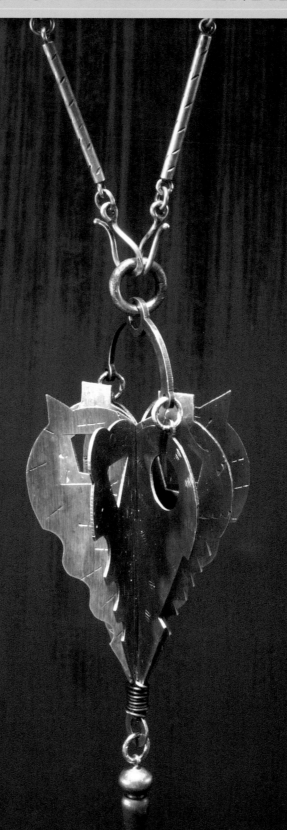

By this point in the sequence of projects you've most likely mastered the slot sawing challenge, so this one will be a piece o' cake! The slot system in this piece is designed to "nest" the plates together in such a way that they created a "finned" result. In order for this finning to work, the separate plates (22g brass, bronze or nickel) have to be slotted into place in the correct order. To keep them in position, a thin wire (22g round steel, copper or silver) is wrapped around the base "fingers" of the plates. You can add a drop from the bottom and then figure out a necklace solution that connects to the two attachment points indicated on one of the plates. You might also texturize the plates before assembly using chasing, etching or a variety of surface finishing burrs or sanding discs. To add depth to those surfaces, I oxidize them with a silver blackening solution (Jax or any other brand, all mildly acidic) or liver of sulfur (but this won't work on the nickel).

WHAT YOU NEED

- Octagonal Slot Heart Pendant pattern (page 139) and rubber cement
- 22 g brass, bronze or nickel sheet, 6" x 8" (15cm x 20cm)
- 16g copper sheet for harness, 2" x 2" (5cm x 5cm)
- drill with no. 60 bit
- chasing tools
- jeweler's saw
- 2/0 saw blades
- bench pin
- bench block
- hammer
- patina such as Jax Black
- steel wool
- rotary file (optional)
- files
- 22g steel binding wire, 6" (15cm)
- needle-nose pliers
- flush cutters
- 16g round wire (any metal), 4" (10cm) for two 2½" (6cm) diameter jump rings

1 Paste up the harness element on 16g copper or bronze sheet, and drill an insertion hole for the top of the element and a couple holes on either end of the harness to later attach jump rings to. Saw it out.

2 Paste the heart fin patterns onto 22g brass sheet and cut out. The shapes you see pierced are suggestions only. Feel free to add or change shapes to suit your taste. With a chisel chase lines or any other surface design you care for on the various fin sides.

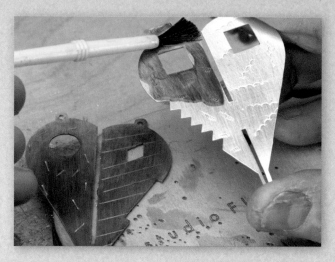

3 Oxidize the brass fin surfaces with silver blackener. On the fin that has the washer shape at the bottom, drill a no. 60 hole at the spot just before it transitions to the flat shaft area below the heart shape. Drill a second hole at the top dead center of the bottom element washer shape.

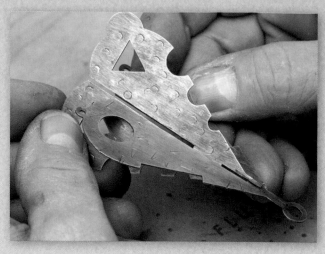

4 Use steel wool to polish up the blackened pieces. If you've precisely SawFiled out the slots of your fin elements, they should slot together easily. Refer to the insertion sequence at the bottom of the project diagram. Fin No. 2 slides into Fin No. 1 at a 45° angle to the right vertical of Fin No. 1.

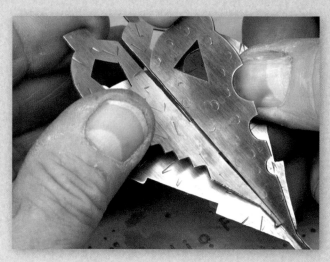

5 Insert Fin No. 3 at a 45° angle to the left vertical of Fin No. 1 and 90° to Fin No. 2. Proceed as previously to a snug fit. Note: If you encounter any resistance as you slide the fins into position, disassemble the fins and check for proper slot-width alignment. You may need to use your saw blade edge or a flat blade needle file to widen the slot.

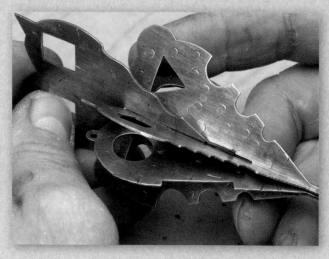

6 And finally insert Fin No. 4 at a 90° angle to Fin No. 1.

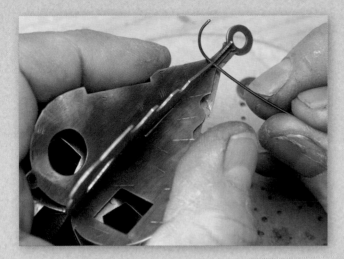

7 At the no. 60 hole you drilled in step 3, insert the end of a 6" (15cm) piece of 22g steel binding wire.

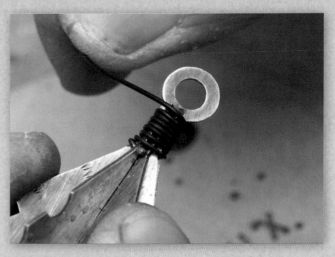

8 Wrap the wire around all three fin element bases, locking them in place.

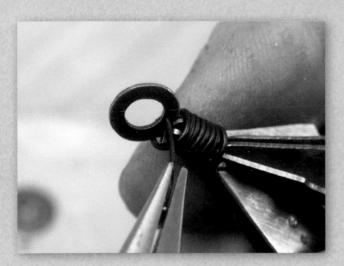

9 Insert the end of the binding wire through the lower hole and pull snug.

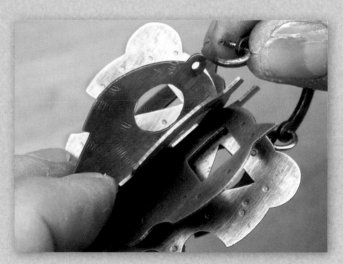

10 Flush cut the wire off, leaving a short (¼" [6mm]) length and tuck it into the coil. Attach the harness element with large jump rings.

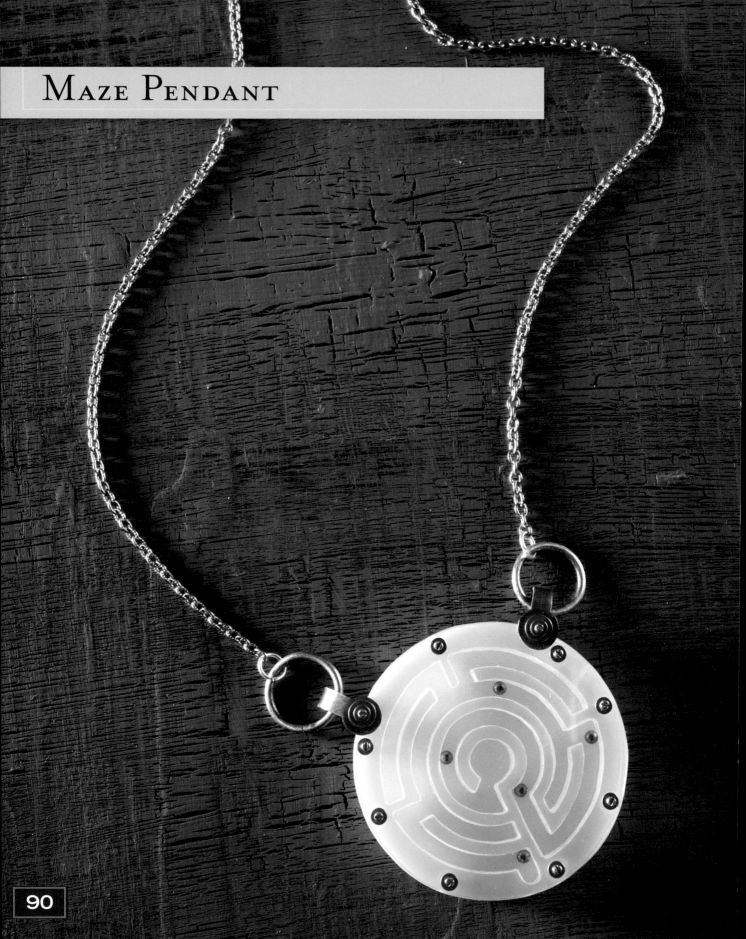

Remember the wooden labyrinth tilt maze game with the two knobs you had when you were a kid? No? Well, I do! This piece is a lot of fun and probably one of the "next level" sawing challenges. The trick here is to saw straight up and down, like you're supposed to, you sawin' demon, you! The fact is, nobody can do it consistently. And while you don't notice the "bevel" effect when you're sawing 22g metal, that bevel becomes painfully obvious when you're sawing through ¼" (6mm) acrylic sheet.

But don't fret. . . . (Get it? Fret saw?) You can do a couple of things to make sure the channel in the maze doesn't pinch the ball and allows it to roll freely. One, constantly correct your vertical sawing motion, realigning it every few strokes, by referring to the ingenious saw frame level (a.k.a., the Tomboy Saw Frame Level Tool) you've mounted (and calibrated) just behind the top compression block of your saw frame. (Oh, don't have one of these invaluable little devices? Check out the Resources on page 140 to order your own kit and make one!) Two, if those channel walls have a bevel in them, then you'll have to use a ⅛" (3mm) diameter cylindrical carbide burr in your flex-shaft handpiece to delicately carve those bevels back to vertical. Good luck and have fun!

WHAT YOU NEED

- Maze Pendant pattern (page 139) and rubber cement
- ¼" (6mm) acrylic sheet (clear or tinted clear), 4" x 4" (10cm x 10cm)
- ⅛" (3mm) acrylic sheet (solid color or translucent), 4" x 4" (10cm x 10cm)
- 1/16" (2mm) acrylic sheet (clear), 4" x 4" (10cm x 10cm)
- 20g metal sheet (any type) for harness, 1" x 3" (3cm x 8cm)
- drill with no. 52 bit
- Tomboy Saw Frame Level Tool (see Resources)
- jeweler's saw
- skip tooth saw blades
- no. 1 saw blades
- 2/0 saw blades
- bench pin
- ½" (13mm), ¼" (6mm) and ⅛" (3mm) diameter rotary files (optional)
- steel wool
- half-round needle file, coarse cut
- files
- ⅛" (3mm) brass balls, 3
- tweezers
- ¾" (19mm) 080 nuts, bolts and washers, 8 ea.
- 080 nut driver
- rivet hammer
- flush cutters
- round/flat-nose pliers

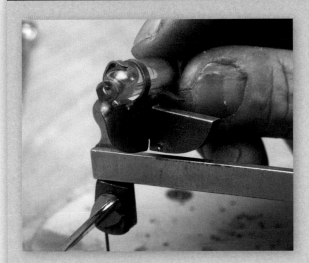

1 Install your Tomboy Saw Frame Leveling Device on the top leg of your saw frame.

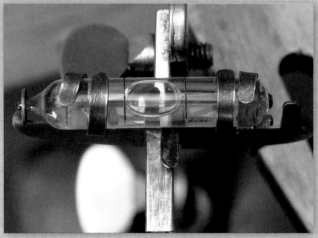

2 Test the level by seeing how the bubble moves when the saw veers from one side to the other, rather than remaining upright.

3 Paste the Maze pattern onto the clear, colored acrylic using rubber cement. Drill a saw blade insertion hole at several places on the maze plan. Insert your saw blade and restring the frame. Use the leveling tool to saw vertically as close to perfect as you can, ensuring the walls of the maze will be straight and not beveled.

4 Do it right and the negative shape will just drop out!

5 In the event that your sawing wasn't as straight as it should have been, and you wish to make the walls of the maze perpendicular to the base of the maze, use a ⅛" (3mm) diameter cylindrical burr to even things out.

6 Drill the primary connection points out with a no. 52 drill. Center on a piece of 22g metal or ⅛" (3mm) colored acrylic that will serve as a backplate, and drill centering divots. Remove the acrylic maze and drill through the divots with the no. 52 drill. Reposition the acrylic maze element and insert ½" (13mm) long 080 stainless steel bolts. Spin on 080 nuts and tighten. Then saw out the plate using the maze element as a sawing guide.

7 Reverse this process with the ¹⁄₁₆" (2mm) clear acrylic cover lens, working on the reverse side of the maze element.

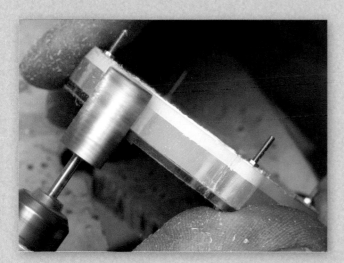

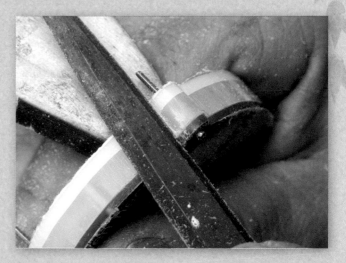

8 Disassemble and then reassemble all layers together, hand-tightening the nuts. Edge finish the sandwich, using a rotary file burr (large cylindrical burr).

9 Alternatively, you can hand file the edges. (Pictured: 4" [10cm] no. 2 crosscut barrette file.)

10 Polish the filed edge with medium steel wool to a final finish.

11 Paste the Harness pattern onto 22g metal sheet and then saw out the two pieces.

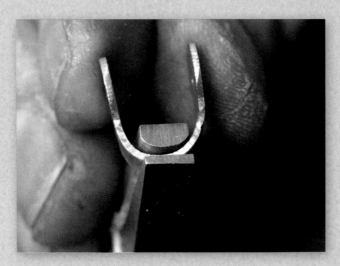

12 Gently bend the harnesses with round/flat-nose pliers into a U shape.

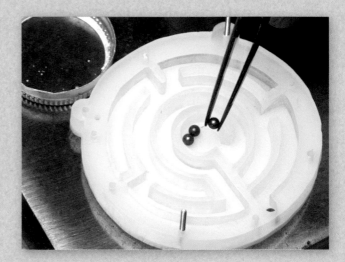

13 Disassemble the sandwich, deburr all of the elements, carefully clean and dust all of the elements, and then gently align the backplate and maze component with a couple of bolts. With a tweezer, insert the ⅛" (3mm) brass balls into the maze.

14 After checking for dust or lint, gently position the clear acrylic lens, over the two bolts.

15 Lightly tighten two nuts onto the bolts. This is a temporary assembly. Now insert the remaining bolts from the front of the sandwich to the back and spin on all the 080 nuts. Reverse the direction of the previous two bolts and secure the metal harness pieces to the "ears" of the maze sandwich. Trim the excess bolt length off at each nut rear surface with flush cutters.

16 Do a final tightening with your 080 nut driver tool.

17 Then flip the assembled unit over and carefully position each bolt head against the block and lightly collapse the small nib of bolt material left by the flush cutter with the flat face of your rivet hammer.

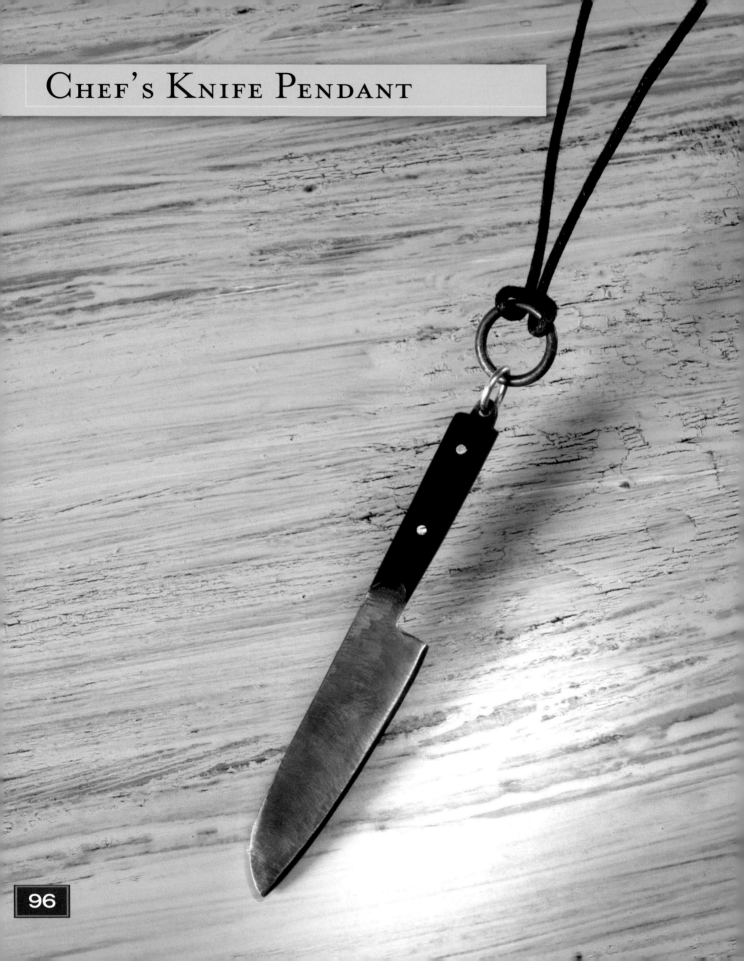

Some years ago, a chef friend of mine from Canada invited me to a dinner she was preparing at the James Beard House in New York. It was an amazing meal and experience. I clearly remember the Ciroc (grape vodka) martinis with frozen grapes! To thank her for that opportunity, I made her a pair of chef's knife earrings. So when I was thinking about projects for this book—and wanted to demonstrate the range of materials you can cut with the jeweler's saw, from paper to steel—I remembered those chef's knife earrings.

So let's make a chef's knife pendant out of steel with a black acrylic handle. You'll want to locate some $^1/_{16}$" to $^1/_8$" (2mm to 3mm) mild steel sheet, available at your local hardware megamart in those raw steel and aluminum material racks. Here's a little tip: Saw *slow*, and saw *lubricated*. This is one of those rare situations where I actually recommend the use of a wax lubricant on your saw blade. I guarantee it will make a difference. Be patient, be persistent, Saw Where Y'at, and you'll get through it. It took me fifteen minutes of continuous sawing to bust the blade shape out of the steel plate—about four times as long as it would have taken me if I were sawing brass or silver!

Hey, you don't want to saw steel? Cut it out of anything you care to; it's cool with me. You can cut the blanks for the handles from any material that will hold up to riveting. I just like the black acrylic. Saw the outside of the pattern design line on these because you want them to be slightly larger than the "tang" of the knife blade blank, because you're going be grinding them back to match the tang's outline.

1 Paste your blade pattern on 12g steel sheet or to any other metal you choose. Drill the two holes for attaching the acrylic handle pieces using a no. 55 drill bit. Saw the blade out. Steel will be challenging to saw, but have patience; it will take you a bit of time.

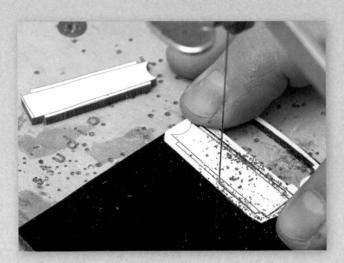

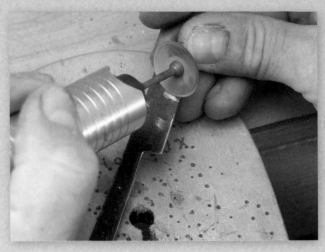

2 Paste the handle pattern onto the black acrylic and saw out the handle pieces. They should be just slightly larger than the actual tang of the blade so they can later be ground back to a flush fit with the blade.

3 Use a snap-on sanding disc to sand a clean surface over the blade blank and to create a beveled blade. (Keep in mind it doesn't actually need to be sharp enough to cut anything.)

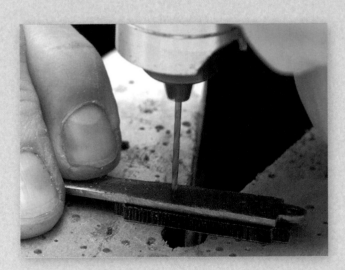

4 Using the tang of the blade piece, align it over one handle blank and drill one no. 55 hole.

5 Insert a temporary 16g copper rivet and then drill the second hole, again, using the blade tang as a guide. Match the handle blank up with the second handle blank and, using the holes you just made as a guide, drill the first hole through the second handle blank.

6 Insert a temporary 16g copper rivet.

7 Drill the second hole through the second blank, using the top blank's hole as a guide.

8 At the top of the handles, create a bevel that will taper down to the blade when it's between the handle blanks. To do this, you can file the acrylic down or use a burr grinder.

9 Use a ball burr or a countersink burr to grind in a countersunk space in each exterior handle rivet hole. This will allow for the expansion on the rivet head and shaft into that space and, eventually, a flat rivet head surface finish.

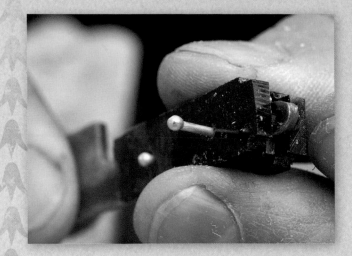

10 Position the tapered handle halves in alignment with the tang rivet holes and insert 16g silver rivets.

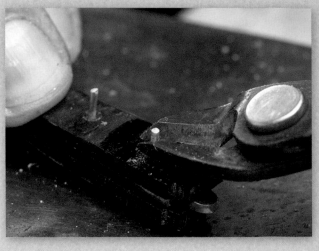

11 Using flush cutters, trim the excess rivet wires.

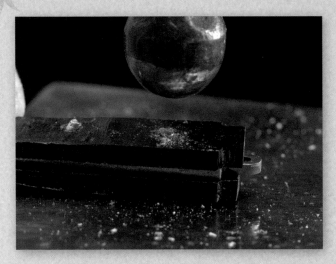

12 Hammer the rivets gently but precisely. The goal is to expand the rivet material into the countersinks.

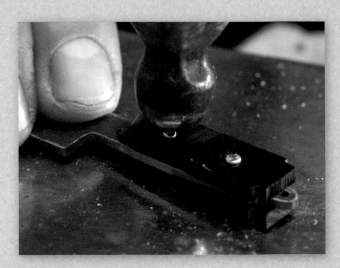

13 Turn the handle over and gently flatten the rivets into the countersink holes on the other side.

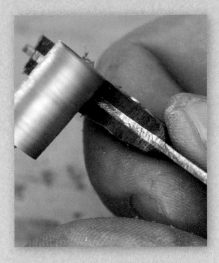

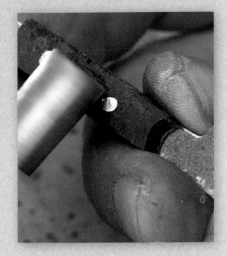

14 Trim the excess handle material back to the knife handle tang by first sawing off the bulk of the excess material.

15 Then grind or file the acrylic back to the tang's surface.

16 Do the same with the surface, grinding or filing back the rivet head material to the handle surface so it's completely flush and smooth.

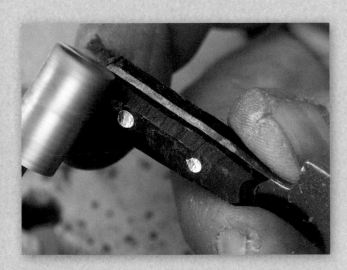

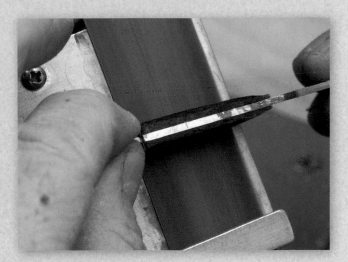

17 Use the burr grinder or a file to add a bevel to the edges of the handle.

18 Beltsand all surfaces with 120–180 grit paper in the sander.

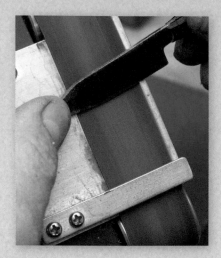

19 Sand an edge—but not too sharp of one—on the blade of the knife.

20 Detail file all surfaces and edges of the knife.

21 Use steel wool on all surfaces to polish.

22 Using pliers, add one jump ring to the end of the handle and string it up. You're done!

Steel Blank

Trim Flanges

Chef's Knife Pattern
[copy at 100%]

Metal Artist BENCH PIN

Kristin Diener

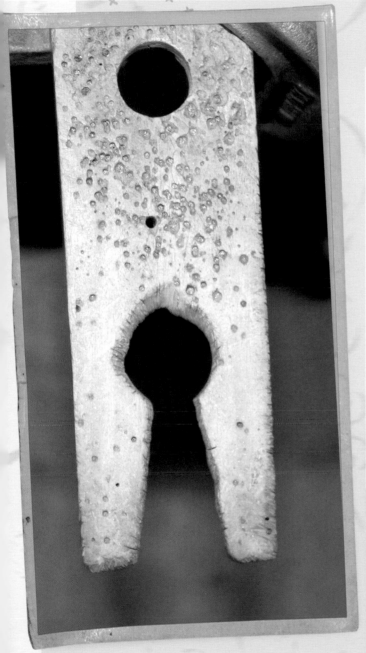

My jeweler's saw frame and bench pin are my friends! I have a few tools from my very first jewelry class that I do not share with students when I teach classes. I do not share my jeweler's saw frame, my bench pin with C-clamp, 4 crappy little pliers, a well-used chopstick that makes a favorite-sized jump ring, and a beautiful file that has very few teeth left on it—everything else, no problem!

My bench pin and saw frame have a great feel that is sort of sacred to me. I know on one level this is sort of silly because I can saw with any saw and use any bench pin and if they disappeared tomorrow I would replace them, but these particular items have a lot of history—present and future in them—and they feel really good in my hands; I know exactly what to do with them and how they behave and inform the metalwork.

www.kristindiener.com

The Guardian

103

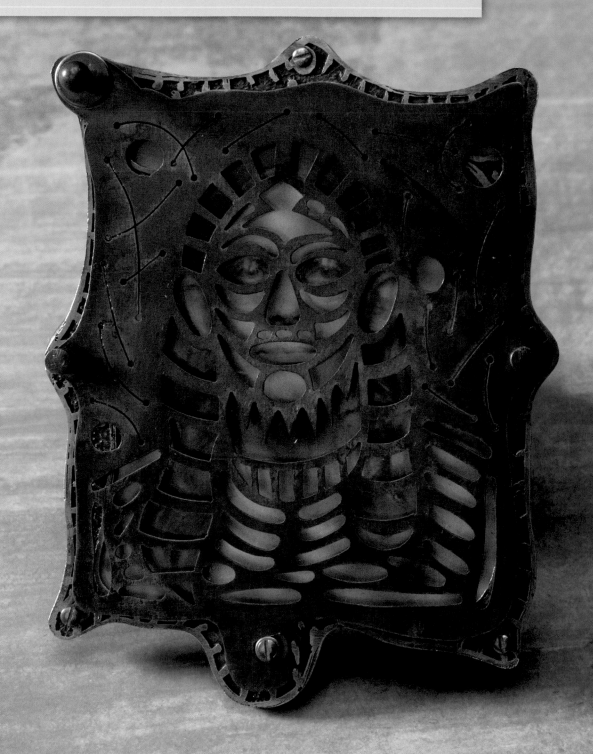

There's a whole lotta piercin' goin' on in this project! And you pretty much have to design your own "screen" because it's *your self-portrait*, not mine. Following the artistic tradition of making periodic self-portrait works, I have been subjecting my own image to the same visual torture I've put numerous anonymous characters through over my career. This photo assemblage brooch follows closely the "Found Object Sandwich" technique I teach in workshops with the added component of the swiveling screen—a nifty addition.

I have always loved the Moorish architectural device of the latticed window treatment used to filter sunlight into interior spaces. The most notable of these screens is evident in the beautifully detailed surfaces in the Alhambra in Granada, Spain. But, I find even the simplest latticed window treatment equally interesting. I encourage you to "go wild" designing your own screen.

WHAT YOU NEED

- Self-Portrait Pin pattern (yours) and rubber cement
- 22g brass, bronze or nickel sheet for photo frame and screen
- 1/16" (2mm) clear acrylic sheet
- 24g patterned metal sheet for backplate
- drill with no. 55 bit
- jeweler's saw
- 2/0 saw blades
- bench pin
- paint pens, various widths for photo frame design resist
- clear packing tape
- foam block
- craft knife
- ferric chloride
- etchant, approximately 1 quart
- double-stick tape
- water
- baking soda
- steel wool
- wood bench block
- 1/2" (13mm) 16g copper rivets
- rivet hammer
- rotary file (optional)
- files
- pin back
- steel bench block
- 080 nuts, bolts and washers
- flush cutters
- chasing tools (optional)
- patina such as Jax Black

MAKING A SCREEN TEMPLATE

I was able to accomplish this very intricate lattice pattern by:

1. Scanning my picture into a photo-manipulating program, enlarging it to full-page size and removing the color. I then printed out several copies.

2. I drew what I wanted to be the screen directly on the printouts, redoing it several times until I was happy with the result.

3. Then I put the finished design on a light table, layered over it a clean sheet of copy paper and traced the screen design onto it.

4. I scanned the tracing into the program again and reduced it to fit the size of my original image. I did this by copy/pasting both the original and the drawing into a new full-page canvas, then decreased the opacity of the lattice screen layer to 50%. I then drug it over my original and held the Option/Shift key combo to drag any corner of that layer until it fit my original precisely.

5. I printed out a copy of the screen on copy paper, and a copy of the photo on photo paper.

1 Print out your template design (see the sidebar on page 105), and paste it on a 22g sheet. Drill saw blade pass holes in all areas to be pierced out.

2 You are now a piercing demon! This may take you a while, so be patient. In addition to sawing out the negative spaces, you will also need to drill a no. 55 hole at the top corner where you want the screen to pivot on the frame façade layer.

3 Paste your frame façade pattern (based on your personal design) onto 22g metal sheet and saw it out.

4 To chemically etch your façade, start by creating the etched design on the metal with a fine-point paint pen. The paint will become the resist.

5 To complete the etch, you will need to gather clear packing tape, a small scrap of foam, a craft knife and a container of etchant solution.

6 Apply clear packing tape to the back of the resist/painted façade layer and broadly trim it out.

7 Attach a small block of foam to the center of the taped back of the frame, using double-stick tape. This will act as a handle for placing and removing the frame in and from the etchant bath.

8 Float the façade layer face down in the etchant bath (ferric chloride).

9 After several minutes, check the etch. Using the point of your craft knife, check the depth of the etch by scraping along a resist edge. You may want a light etch or a deeper one—it's up to you.

10 Rinse off the solution with water.

11 Then ensure the etching process has stopped by neutralizing the surface in a bath of baking soda.

12 Use steel wool to scrub off the paint pen resist.

13 Set the screen layer in place over the etched piece and, using the pivot hole in the screen as a guide, drill a no. 55 hole in the façade layer. Also drill a hole at the point that will hold a rivet to catch a hook on the screen.

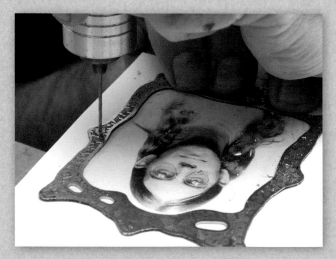

14 Gently position the screen layer onto your primary image as it sits on a wood block. Drill holes through the paper at the pivot point hole and the catch hole.

15 Carefully remove the screen and replace it with the façade layer. Insert a 16g copper rivet in each hole. Now drill no. 55 holes in the remaining holes of the façade layer.

16 Set the façade layer onto a piece of acrylic. Drill one no. 55 hole at one of the holes for the rivets. Insert a temporary 16g copper rivet into this hole.

17 Proceed to drill the remaining holes through the acrylic.

18 Repeat steps 16–17 for the metal sheet back layer.

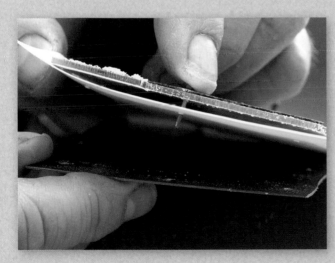

19 Sandwich the façade layer, the acrylic layer, the image and the backplate layer together, aligning the holes, and insert temporary rivets through each hole. Note: If your alignment is off, run your no. 55 drill through all the layers to correct the alignment.

20 Fold over the temporary rivets with a hammer to secure the package together.

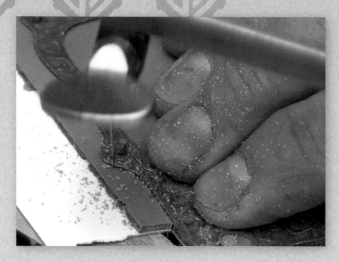

21 Using the façade layer as a sawing guide, precisely SawFile out the sandwiched layers.

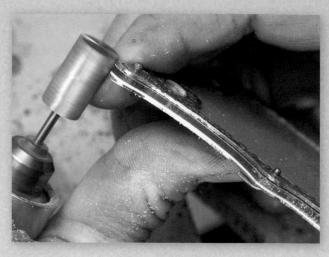

22 Smooth all four layers together, using a rotary file to remove the saw marks.

23 Using steel wool, polish all of the edges to a smooth finish.

24 Straighten out the temporary rivets and remove them.

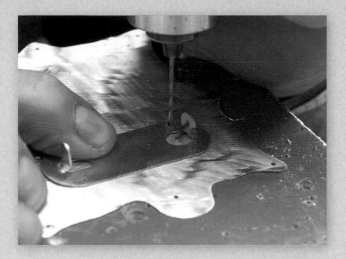

25 Using the pin back as a template, position it in the top third of the backplate. Hold it in place and drill one no. 55 rivet hole.

26 Insert a 16g copper rivet through the pin back element and back layer of your pin. Flip it over and position it on your steel bench block. Trim the rivet shaft off with your flush cutter leaving 1/32" (1mm) of revealed rivet shaft. Set the rivet with the peen face of your rivet hammer. Repeat for the remaining three holes in the pin back.

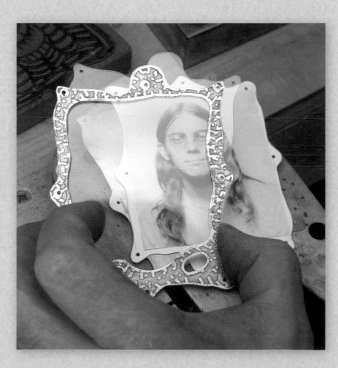

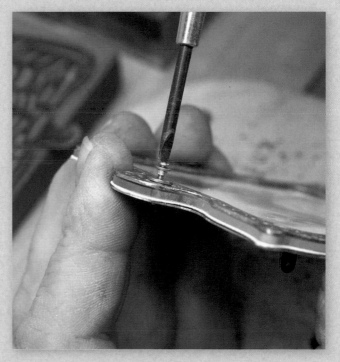

27 Remove the protective paper from the lens layer and align all the layers with the back layer. You'll want to sandwich the lens layer and image layer together first to prevent dust intrusion.

28 Insert 080 bolts in each of the appropriate holes and spin on 080 nuts making sure all the layers remain in alignment.

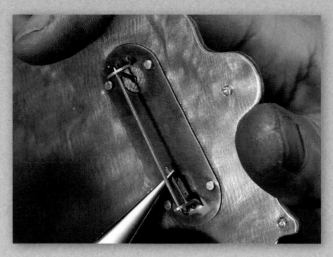

29 Trim off the excess bolt lengths with your flush cutters at the nut surface, invert onto your steel bench block and lightly set the remaining nip with the flat face of your rivet hammer.

Trim off the excess bolt length from the pivot bolt stanchion point with your flush cutter, invert the package onto your steel bench block and lightly set the remaining nib with the flat face of your rivet hammer. Do the same with the catch point stanchion at the bottom of your pin after you have checked for its proper alignment with the catch opening in the screen layer.

30 Insert the pin stem in the pin back, align with the catch and set.

Self Portrait stencil example

Metal Artist BENCH PIN

Michael David Sturlin

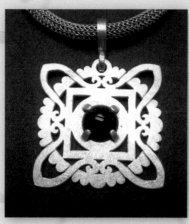

Mandala Pendant

As a minimalist—in both my design aesthetic and philosophical approach to the studio practice—the saw is the most simple and functional tool on my bench. If we had to choose only one tool to make jewelry, the most extensive body of work can be created with this single implement than any other.

Sawing and piercing is a meditative exercise in efficiency of movement and mindful application of tool on metal. The greatest possibility for endless design is available through this one simple tool.

www.ganoksin.com/blog/
michaelsturlinstudio

Jesse Bert

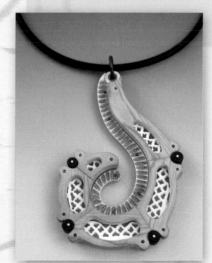

Hablando

My saw frame is a tool that I use to translate the ethereal, creative ideas in my mind into something direct, physical and tangible. For me, my bench pin represents an important part of my daily output; it is one of the main elements of my jeweler's workstation. It is also something very personal to me because my father is a woodworker and ever since I started working with jewelry he has made my bench pins. The particular bench pin that I am using right now is made out of American chestnut my father salvaged from one of his job sites.

www.jessebert.com

My dad's shop-parts organization was dominated by cigar box solutions, so when I started making models and then kit-bashing them, I stored all of those plastic parts and tools in cigar boxes. In the late '70s, when I started making the photo assemblage pins that propelled the "Techno-Romantic" style, those cigar boxes became an important part of the "found object" approach I employed. I turned them from parts storage into jewelry/object presentation devices.

To saw out a box lid you'll need to use a saw frame with a deep enough "throat" to saw around the flattened back, open lid. Here, I'm using a 12" (30cm) model. A deeper frame size requires a higher degree of "tool awareness" to operate without breaking a lot of blades, so . . . practice, practice, practice.

WHAT YOU NEED

- cigar box
- Cigar Box Opening and Lens pattern (yours) and rubber cement
- ¹⁄₁₆" (2mm) clear acrylic sheet
- drill with no. 52 bit
- jeweler's saw
- 2/0 saw blades
- bench pin
- files
- sandpaper
- rotary file (optional)
- steel wool
- masking tape
- 080 nuts, bolts and washers
- galvanized steel sheet
- ½"–¾" (13mm–19mm) scrap of pine or plywood
- escutcheon pins
- hot glue gun
- MagnaPin set

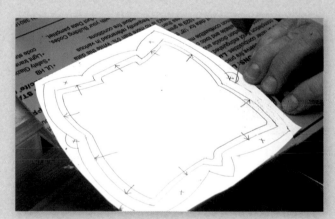

1 Draw the design for the window opening and the clear acrylic lens that will cover it. The inside dimension (ID) of the window in the box lid will be smaller than the outside dimension (OD) of the clear acrylic lens cover. I draw both the ID and OD design together, photocopy the original and paste it up with rubber cement on the still-protected ¹⁄₁₆" (2mm) acrylic sheet.

Saw out along the exterior line to extract the lens from the acrylic sheet.

(Note: It's helpful to indicate the position of the mounting screw holes and drill them out with a no. 52 drill bit before removing the design paper from the acrylic.)

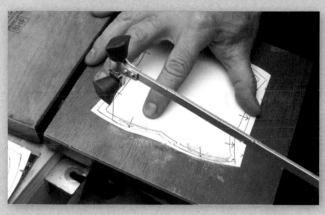

2 Either peel the pattern off the acrylic and repaste it onto the lid of the box, or use a second copy or the original pattern. Drill one or several saw blade pass holes and "pierce" out the window opening. You may have to, or want to, treat the sawn exterior edge of that opening with a file to deburr it of little splinters. Sandpaper may work just as well, depending on the type of material the box is made of.

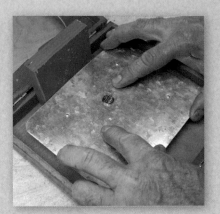

3 Finish the edge of the acrylic lens cover by filing or sanding and steel-wooling, before you peel off its protective covering. From this point forward, handle it with care to prevent scratches. I recommend "marking" those hole positions through the lens and then removing it and drilling all the marked holes, though I didn't do this in this illustration. But using some masking tape to position the lens so it doesn't move on you as you mark the holes is probably a good idea. Finally, de-dust the lens and the box frame with compressed air or whatever method works. Then mount the lens using 080 bolts, washers and nuts.

4 To make the magnetic mounting block, you'll need a sheet of galvanized steel (from the hardware megamart), a small block of plywood at least ½" (13mm) thick, some little brass nails (escutcheon pins) and a hot glue gun. Cut the galvanized sheet to fit the interior of the box so its edges are not visible behind the window opening. Center it on the plywood block and drill four no. 52 holes at the corners. Mount the sheet to the block with the brass nails. Place the assembly in the well of the box frame. Check for its proper alignment with the window opening and make some pencil marks at its corners. Push some hot glue onto the back of the plywood block.

5 Press the block into the box relative to the alignment marks. (Note: You can paint the galvanized sheet with whatever kind of paint you wish, or use any other metal as long as it is ferrous in nature [meaning it's magnetic]).

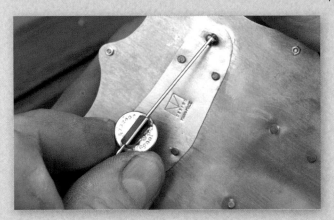

6 Slide on a MagnaPin magnet device, close the pin stem into the catch and you're ready to place it in the completed box frame.

7 Ta-da!

Metal Artist BENCH PIN

Diane Weimer

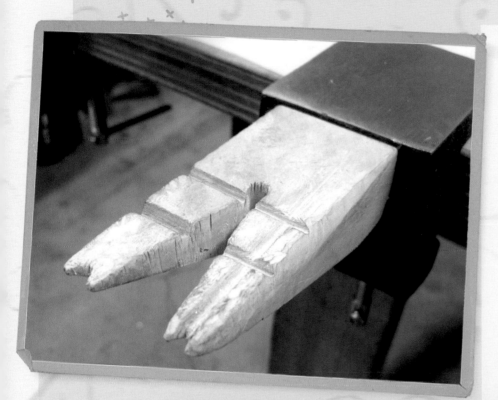

THE CURVE OF AN OCEAN WAVE THAT SPRINGS FROM THE SEA, THE undulating mountaintops of the Appalachians on the East Coast or the contour line of a wisp of smoke inspires my metal work. The rhythm of the saw mesmerizes me and I am in the zone.

As the blade cuts through the sterling, there is a perfect spot on the bench pin where, it seems, the blade slices through the metal like butter.

www.etsy.com/shop/DianeWeimer

Russian Lace Pendant

117

CALDER SPOONS

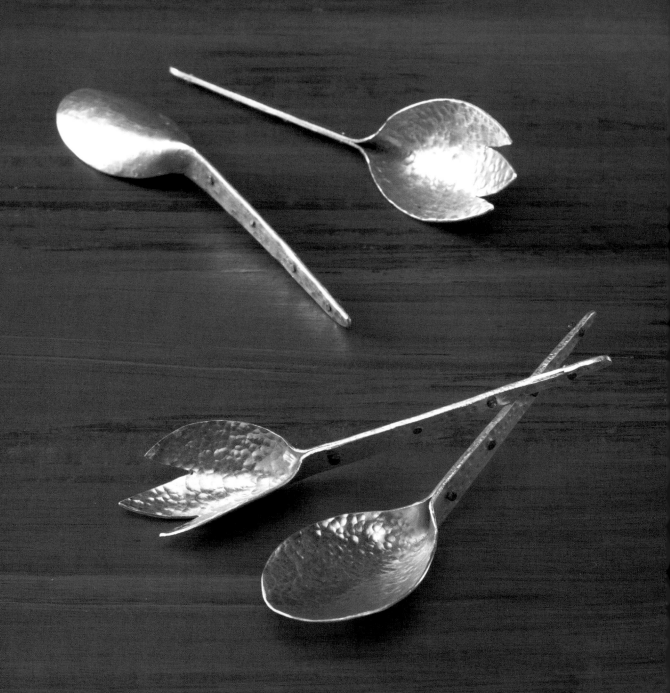

There are no words that can adequately describe the profound effect that Alexander (Sandy) Calder delivered to this young artist. He was, and continues to be, an inspiring force in my life, along with Joseph Cornell, Max Ernst, Marcel Duchamp, and many others. But Sandy's influence over me was due to more than just who he was as an artist. His lifestyle and career path provided a model for me to follow

One of the most intriguing things I learned about his home life, was that he made most of the cooking utensils that his wife used in their country kitchen. Some were made of wire, others of aluminum sheet. Though they looked similar, there were no patterns; Calder always made them spontaneously. You can make a version of his wonderful utensils simply by using the patterns provided here. Look up Calder's work and check out the photographs of the Roxbury kitchen. You'll see these spoon shapes hanging all about the woodstove. Just imagine them spooning out a delicious soup!

WHAT YOU NEED

- Calder Spoon pattern (page 122) and rubber cement
- 1/16" (2mm) aluminum sheet, 4" x 6" (10cm x 15cm)
- jeweler's saw
- 2/0 saw blades
- bench pin
- inverted cone burr or triangular needle file
- rivet hammer
- planishing hammer
- sandbag or concave wood block
- bench vise
- towel
- steel bench block
- drill with no. 55 bit
- 16g copper rivets
- flush cutters
- 1/2" (13mm) diameter rotary files (optional)
- files

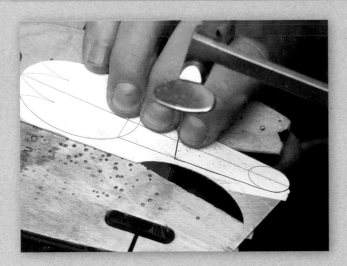

1 Paste the patterns (two copies) onto a 1/16" (2mm) aluminum sheet and saw out the spoon shapes. (Note: Cut one shape as a spoon and one as a fork.)

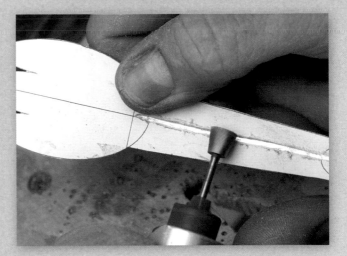

2 Using an inverted cone burr, score a relief channel down the center of the handle.

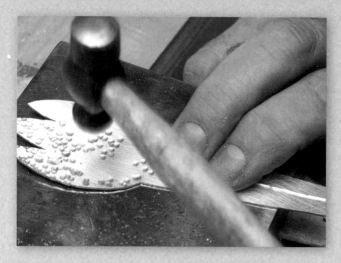

3 Remove the pattern paper and then texture the bowl portion with the ball peen head of your rivet hammer.

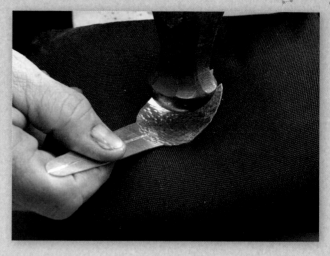

4 Shape the spoon slightly using the peening head of a large planishing hammer while resting the spoon on a sandbag or concave wood block.

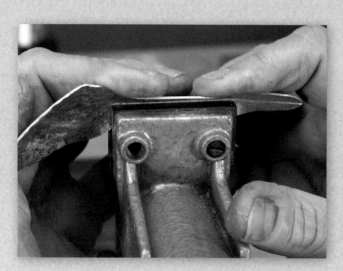

5 Secure the handle in a vise, aligning the relief channel with the straight line of the jaws. Gently fold the exposed edge toward the vise surface.

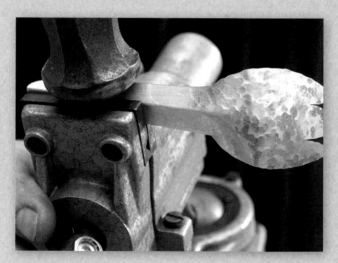

6 Gently collapse the fold further with the flat face of the planishing hammer.

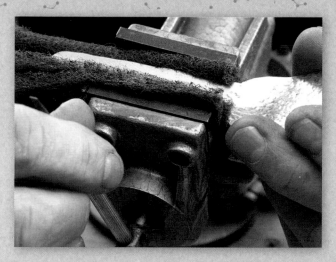

7 Reposition the handle in the vise to squeeze it shut as you tighten the vise. I like to protect the handle form at this point by keeping it inside of a towel or scrub pad.

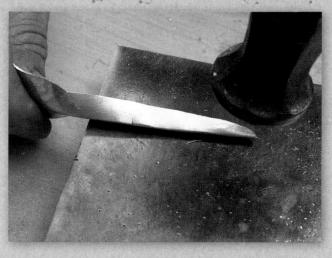

8 Flatten the handle on a steel block, using the flat face of a hammer.

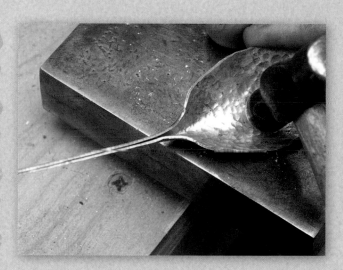

9 Add any further desired texture to the bowl and the handle, using the ball peen head of the rivet hammer.

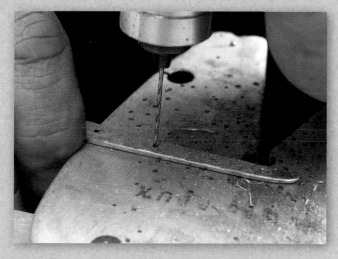

10 Drill no. 55 holes along the handle length. (I made four, but make as many or few as you like.)

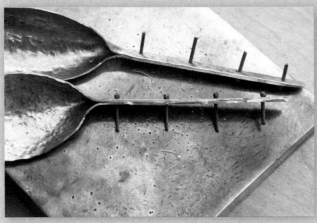

11 Insert 16g copper rivets.

12 Trim and set the rivets.

13 File all the edges.

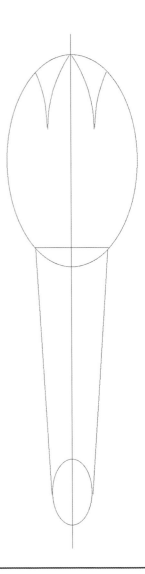

Calder Spoon
[enlarge 150% or as desired]

Metal Artist BENCH PIN

Forbidden Fruit

Aliya Gold

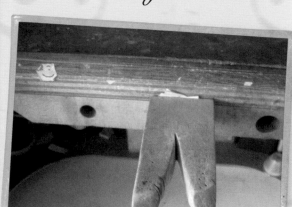

I USE MY SAW AS IF IT WERE AN EXTENSION OF MY HAND. IN FACT when the handle broke I refused to buy a new one. Thank goodness for epoxy.

My bench pin on the other hand, I tend to abuse under the notion that sacrifices must be made in order to get the job done. I dread the day when there is nothing left of my bench pin and I must make a new one, but then I suppose the journey begins all over again.

www.aliyahgold.com

Sarah Mann

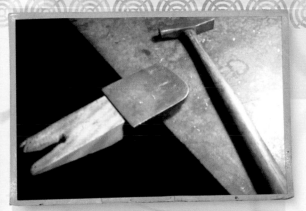

Dinky Creatures for My Daughter, Stella

MY SAW HAS BEEN THE SOURCE OF INSPIRATION AND EXASPERATION. IT has converted straight edges to curves and solid metal surfaces to perforated, lacey ones. It has altered metal in more ways over the years than any of my other tools and is an essential member of my tool family.

I had my first bench pin for over a decade. It had been slowly and steadily whittled to a burnished nub. When it finally registered that I was working with an inefficient tool, I switched it out for a fresh bench pin that had been waiting patiently in a drawer. The crisp edged, unblemished surface felt so foreign to work on that after a day of attempting to get into a groove with it, I ended up tossing it back into the drawer and reclaiming the comfort and familiarity that my old one provided. Eventually, I did replace the old with the new but I could never throw out my trusty first bench pin, it represents too many hours of toil and triumph.

www.mannstudio.com

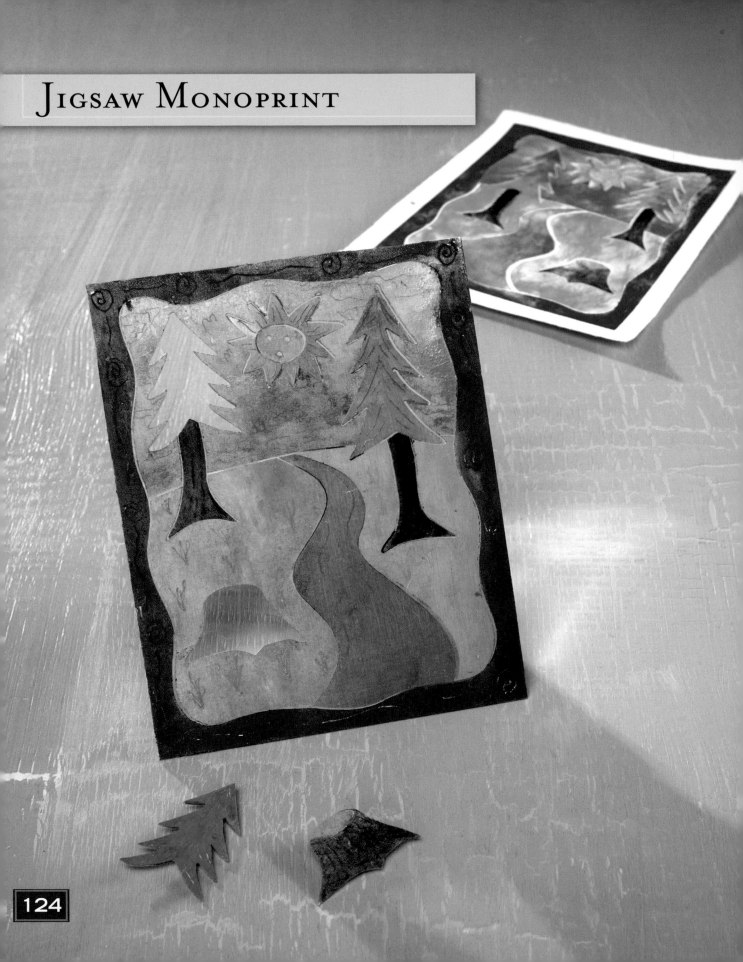

I attended junior high and high school back in an era when one could "major" in art during those earlier learning years. I can remember a semester of printmaking and how intriguing I found the process. I had the opportunity to try my hand at every printing technique: wood blocks, dry point and chemical etching, monoprints and lithography.

Recently I had the chance to visit my friend and sculptor colleague, John Martini, and his photo-gravure-printing-expert partner, Carol Munder, at their home and studios in the French countryside south of Paris. They left on a trip for a week, leaving me alone to work in their studios, one of which is a printmaking shop with a very nice etching press.

I started playing around doing monoprints on acrylic sheet. I'd brought along some aluminum sheet and tried that too. Then it occurred to me to cut the aluminum apart and ink the elements separately, put them back together on the press bed and pull a print. Wow . . . what a cool effect and twist on the traditional process! Try it out and have some fun. I sure did!

WHAT YOU NEED

- Jigsaw Monoprint pattern (yours or mine [page 128]) and rubber cement
- $\frac{1}{16}$" (2mm) aluminum sheet, 4" x 8" (10cm x 20cm)
- drill with no. 52 bit
- jeweler's saw
- 2/0 saw blades
- bench pin
- files
- etching tool
- printing inks
- acrylic sheet (for ink palette)
- rubber gloves
- tweezers
- water bath
- paper towels
- art papers suitable for printing (I like Arches watercolor paper)
- brayer

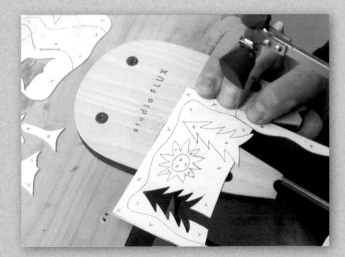

1 Create a simple drawing of shapes and print it out on copy paper (or use the included pattern). Paste the design onto a $\frac{1}{16}$" (2mm) aluminum sheet and drill blade insertion holes at inconspicuous points in each shape. Saw out all of the elements.

2 Use a file to finish the edges of all the pieces. Using an etching tool (here I'm using a Dremel), inscribe each element with a bit of line detail.

3 Lay out a palette of either water- or oil-based etching/printing inks. I like to use a piece of acrylic sheet for a palette.

4 Gently apply inks to the individual shapes using your fingertips (you may wish to wear gloves). After the shapes are inked-up, return them to their home in the puzzle.

5 You may find it easier to use tweezers to put the shapes back carefully without smudging the ink.

6 Soak a few sheets of watercolor paper (I prefer Arches) in a bath of water. Pull out one sheet and let the water drain off of it.

7 Sandwich the wet paper between paper towels and blot off the remaining excess water by running a brayer over the surface.

8 Carefully center the damp paper over your jigsaw plate.

9 Cover with a clean, dry watercolor sheet, and then roll the brayer, with pressure, over all areas of the plate.

10 If necessary, burnish with a spoon in specific areas for more ink transfer.

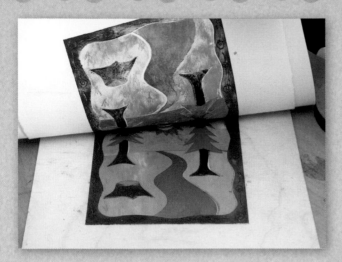

11 Gently peel back the print from the plate.

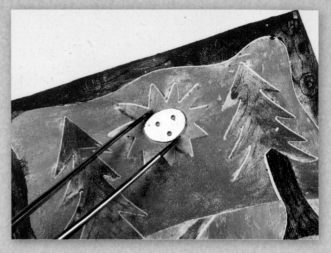

12 Smaller shapes may very well stick to the paper. Gently remove these with tweezers.

13 Reink the pieces and make as many additional prints as you like.

Jigsaw Monoprint
[enlarge 125% or as desired]

Metal Artist BENCH PIN

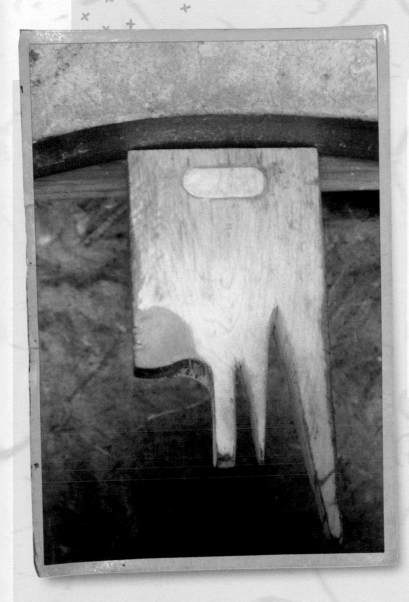

Jeanne Flint

I TRIED A FEW DIFFERENT MODELS BEFORE I FOUND THE ONE THAT WAS just right for me. My saw is an extension of my hand and my best advice for proper sawing is slow and steady.

My benchpin has so many little notches and dings and curves, specific for each task. It is an amazing tool that I use each and every day!

www.jeanneflint.wordpress.com

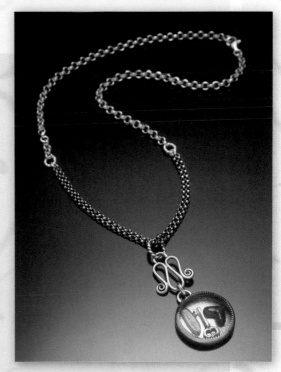

True Love

Saw Everything!

I just couldn't resist going beyond metal, paper and plastic to show you the endless kinds of material you can saw with your jeweler's saw. So here is a bit of fun I had, and I hope it inspires you to try cutting up anything within your reach! (I forgot to include sawing pine boards, galvanized steel sheet, printed circuit boards, fiberglass sheet, tagua nuts and a host of other stuff I know I've sawn with this tool that I just can't pull up right now. Please help me find out all the other things in the world that this tool can saw!)

Keep it Clean

I've covered the bench pin with some clear food wrap. Keep it clean. Wash those hands and the saw frame handle! Keep a bowl of cold water nearby to immerse the slabs in before sawing and for the cutouts afterward.

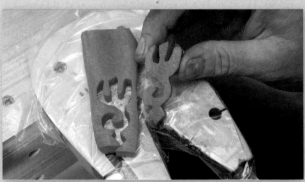

1 If you love to decorate your food presentations with exotic edible cutouts that you usually make with cookie cutters or intricate knife cuts, here's a great alternative. Start by cutting out a decorative shape. I just freehanded this carrot shape as I went.

2 If you cut a relatively thick slab to start with—¼" to ½" (6mm to 13mm)—then you can split that thickness into slices and get multiples of the design.

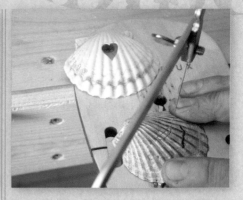

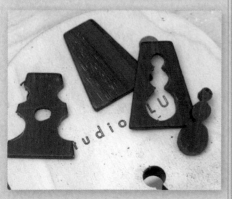

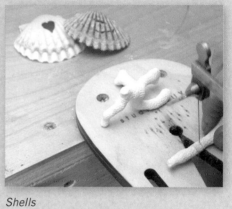

Printed Tin Canisters

Shells

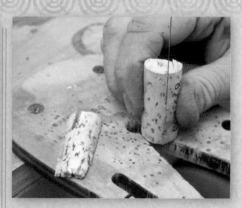

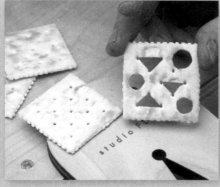

Wood Laminate

Saltine Crackers

Wine Cork

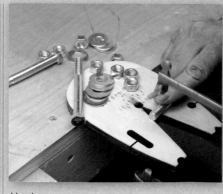

Leather

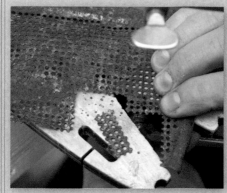

Hardware

Soap

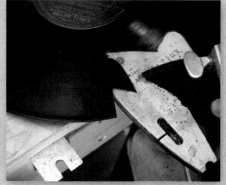

Vinyl Record

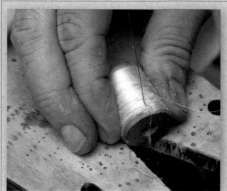

Rusted Screen

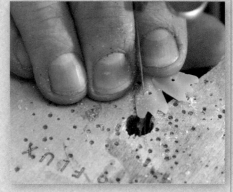

Pasta

Model Airplane

Spool of Thread

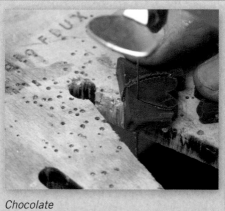

Chocolate

Metal Artist BENCH PIN

Alan Revere

Peek-a-Boo Keyhole Ring

MY SAW WAS ONE OF THE FIRST TEN TOOLS I PURCHASED FOR GOLDSMITHING SCHOOL in Germany. A truly transformational tool, a saw enables me to cut through metal, engrave, file, score, crease, texture and even drill through metal.

My bench pin and I are best friends. We work together, support each other and collaborate to create wonderful things, despite the fact that I drill, saw, file, carve, lean on and eventually wear away the wood. That's what it's there for.

www.revereacademy.com/about/
faculty/alan-revere

Margo Manning

I LIKE TO USE A BENCH PIN THAT IS PORTABLE, AS I OFTEN SAW outside of my studio. It is a great way to get work done in other places because sawing requires so few tools and materials. The primary bench pin I use also has a bench block attached, so some hammering, riveting and stamping can be done. I have a sentimental attachment to old and overly drilled bench pins and drill blocks. They can be very beautiful and take on a life of their own.

www.bayoudesigns.com/margomanning

Stars and Stripes Heart Pin

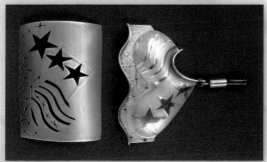

"Rust Never Sleeps" Tryptich
(No. 1 of 3)

I FOUND A LARGE PIECE OF rusted sheet metal along the railroad tracks in New Orleans and when I picked it up it broke apart in three distinct and similarly-sized pieces. I immediately had the vision of a tryptich with the brooch in each being "pierced" from the interior of the rusted sheet. The three pieces employ the same structure but the shape of the brooches vary from a triangle, to a circle and then a square.

Materials: *Rusted steel, acrylic, bronze. Backing frame: Aluminum and acrylics. Pierced, sawn, fabricated with cold connections.*

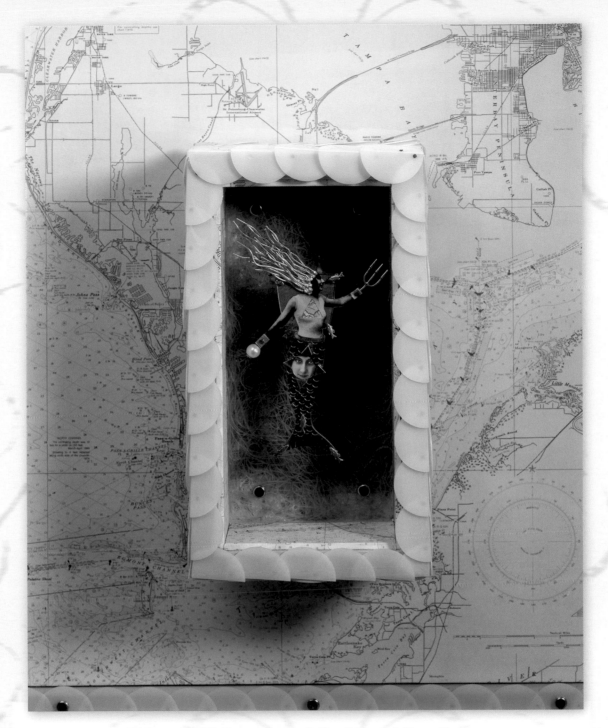

"Mermaid" Brooch and Sculptural Box Frame

THIS PIECE IS ONE OF TEN WALL PIECES FROM A series entitled "Boxes and Booths." Each piece in the series is a brooch in a box mounted on another boxed assemblage (the booth).

Materials: Brooch: *Silver, acrylic, gold leaf, bronze, brass, photos, maps and a pearl. Pierced, sawn, fabricated (soldered and fused) with cold connections. Box frame: wood, aluminum and acrylics.*

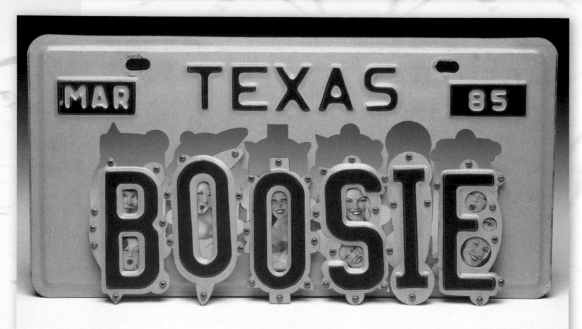

FACADES FOR THESE pins were pierced from a steel license plate.

Materials: *Steel, acrylic, bronze, photo images from postcards. Pierced, sawn, fabricated with cold connections.*

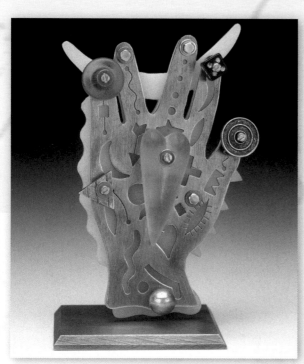

Hand Brooch

Materials: *Nickel, acrylic elements, glow-in-the-dark acrylic, bronze, brass. Pierced, sawn, fabricated with cold connections.*

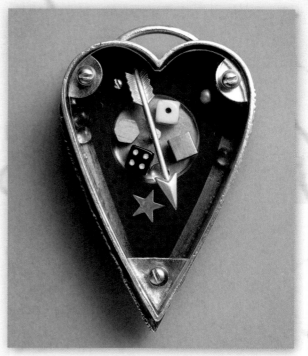

Container Heart Pin

LENS CAN BE REMOVED ALLOWING CONTENTS to change. This piece was chosen to be used in the cover artwork for the PBS program "Craft in America" which I was featured in.

Materials: *Silver, acrylic, found objects. Pierced, sawn, fabricated (soldered and fused) with cold connections.*

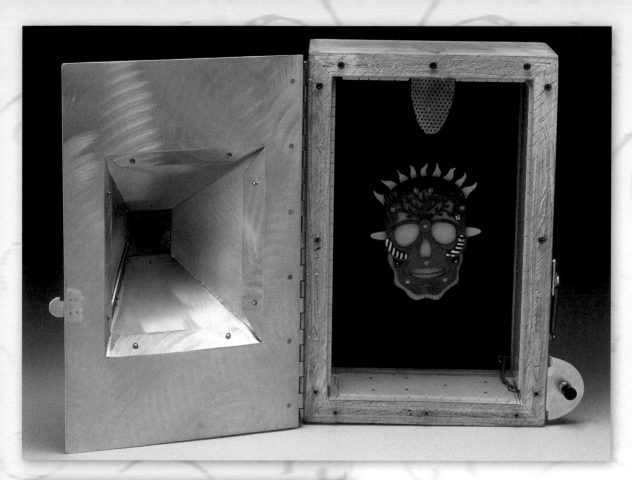

"Dia de los Muertos"
(Day of the Dead)
Brooch and Sculptural Box Frame

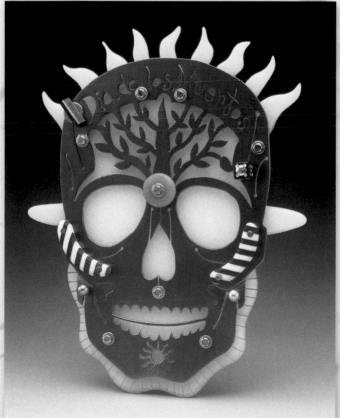

THE FRAME BOX HAS A conical view port installed in its door. When closed the viewer presses the button at the lower right. This ignites a battery-powered lamp that illuminates the brooch and charges the glow-in-the-dark component. When the button is released the pin glows with an eerie light.

Materials: Brooch: *Silver, laminated acrylic, glow-in-the-dark acrylic, bronze, brass. Box frame: wood, aluminum and acrylics. Pierced, sawn, fabricated with cold connections.*

PATTERNS

Light Switch Plate
[enlarge to 133%]

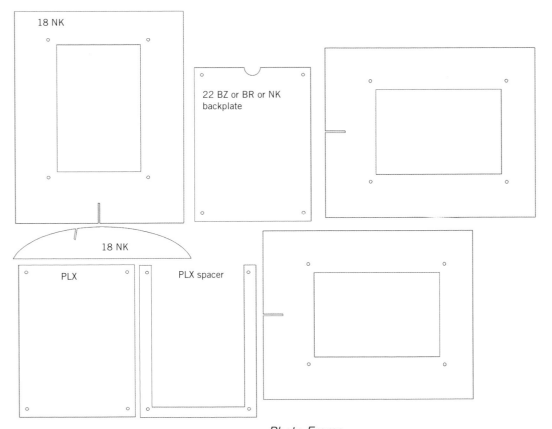

18 NK

22 BZ or BR or NK
backplate

18 NK

PLX

PLX spacer

Photo Frame
[enlarge 150%]

Peg-Leg Slot Sculpture
[enlarge 150%]

Little City
[enlarge 150%]

The slots in this pattern set are designed for 20g metal. If you use metal sheet of any other gauge the slot width must be adjusted for the gauge of the material. Slot drill size: Drill no. 68 to 65 or .032" to .035".
1. Base 2. Building Façade 3. Building Façade 4. Central Platform 5. Platform Arch 6. Central Gateway 7. Tree Unit 1 8. Tree Unit 2 9–10. Platform Legs

Octagonal Slot Heart
Pendant
[enlarge 150%]

Pendant harness/bail

2 — Insert No. 2 plate at this angle
— 1

Insert No. 3 plate at this angle
3 — 2
— 1

Insert No. 4 locking plate at this angle
4
3 — 2
— 1

Note: The slots in this pattern set are designed for 22g metal. If you use metal sheet of any other gauge the slot width must be adjusted for the gauge of the material. The slots for patterns 1–3 are double the dimension of 22g (.025" X 2 = .05"). Pattern 4 slot is .0635". All slots must be proportionally sized up or down relative to these base dimensions.

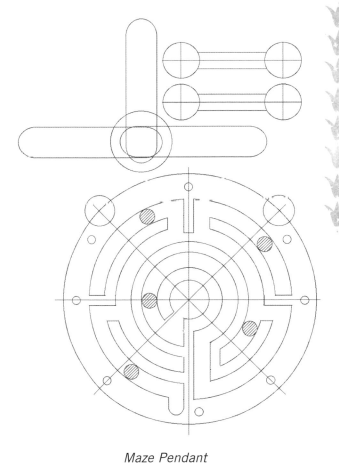

Maze Pendant
[copy at 100%]

**Thomas Mann
StudioFLUX**

1812 Magazine St.
New Orleans, LA 70130
800-875-2113
504-581-2111
thomasmann.com
mystudioFLUX.com
workshops · kits · tools · materials
EasyBild Bench Building Plan
Tomboy Jump Ring Cradle
Tomboy Saw Frame Level Kit

Many of the projects in this book are available from StudioFLUX as kits, which contain all of the materials and tools specific to that project. Individual components of the kits are available as well, in particular: $1/16"$ (2mm) clear acrylic sheet and $1/8"$ (3mm) red acrylic sheet; number drills in all project-indicated sizes; carbide burrs in all project-indicated sizes and shapes.

MagnaPin

magnapin.com
magnetic pin backs

**Lee Marshall
Knew Concepts Saws**

Santa Cruz, CA
831-234-4652
knewconcepts.com
21st-century jeweler's saws

Graphic Chemical & Ink Co.

728 N. Yale Ave.
Villa Park, IL 60181
(630) 832-6004
graphicchemical.com
ferric chloride etchant · printing inks

Etchant product you want from this company:

13650 Copper Etch Solution Tech Grade Ferric Chloride, Tech Grade 42 Baume

Disposal of ferric chloride

Your spent ferric chloride solution cannot be poured down the drain. It must first be neutralized with the addition of either baking soda (sodium carbonate) or sodium hydroxide. The goal is to fix the pH of the solution up to 7.0 or 8.0. You can test the pH with indicator paper available from your local megamart pharmacy. Then dilute the neutralized solution with water and set it aside to allow the sludge to settle out of it. Once this is done you may pour the *liquid* down the drain, but the sludge must be collected in plastic bags and disposed of as hazardous waste (you don't want this sludge in your plumbing system anyway).

INDEX

INDEX (CONTINUED)

THOMAS MANN

These tools are the extensions of these hands.

They, have been making jewelry since I learned how in high school in 1963.

They, have been making my living as a professional artist since 1970.

They, are showing signs of wear now but they still obey the heart that was sent here to make objects of meaning and beauty for those who can see them.

I feel a true sense of mission.

A real sense of purpose.

A sincere obligation to pursue this artistic path.

It is what I am here for.

These tools and these hands are the means to this end.

They are the gateway to the realization of the object.